The Campus History Series

ROLLINS COLLEGE

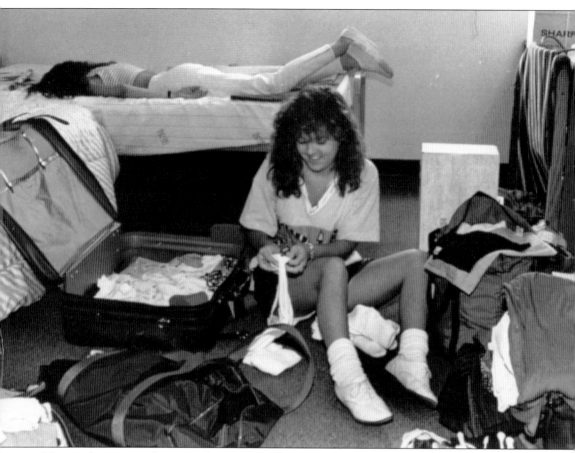

Move-in day is a special coming-of-age moment for Rollins students. Families say goodbye, roommates say hello, and dorm rooms become home. One of Rollins's first students, Fredrick Lewton, fondly remembered his campus residence at Lakeside Cottage in 1886 as "happy and comfortable . . . almost like home." Many decades later, in 2011, a student writer for the *Sandspur* newspaper described freshman orientation and move-in day similarly—as an experience that "exudes the feeling of home regardless of where home actually is." (Courtesy of Rollins College Archives and Special Collections.)

ON THE COVER: Students seen here around 1941 walk along the iconic horseshoe-shaped path at the center of campus while another group converses with "Professor of Books" Edwin Osgood Grover (1926–1947) in front of Lyman Hall. Lyman Hall was built in 1936 and named after Frederick Wolcott Lyman, a founder and charter trustee. Financed largely by a Public Works Administration loan, the building reflects the campus's Spanish Mediterranean architectural style and originally accommodated 27 student residents. Over the years, the building hosted the Rollins Fine Arts House, the Rollins Outdoor Club, and several Greek organizations. (Courtesy of Rollins College Archives and Special Collections.)

COVER BACKGROUND IMAGE: Pres. Thaddeus Seymour (1978–1990) joins students at the Rollins College exit off Interstate 4. Completed in 1965, this major thoroughfare runs across the middle of the state for more than 130 miles and is still the fastest route to the theme parks west of Orlando. While critical for Rollins commuters, this interstate is notoriously congested and labeled one of the most dangerous roads in America. "Thad," as students liked to call him, was a novice magician and self-proclaimed Rollins history buff who insisted on "matching hard work with fun." (Courtesy of Rollins College Archives and Special Collections.)

The Campus History Series

ROLLINS COLLEGE

CLAIRE STROM AND RACHEL WALTON
WITH PEYTON CONNOR, REAGAN COONEY,
HELEN HUTCHINSON, AND LIAM T. KING

ARCADIA
PUBLISHING

Published by Arcadia Publishing
Charleston, South Carolina

Printed in the United States of America

Library of Congress Control Number: 2024930305

For all general information, please contact Arcadia Publishing:
Telephone 843-853-2070
Fax 843-853-0044
E-mail sales@arcadiapublishing.com

Visit us on the Internet at www.arcadiapublishing.com

We dedicate this book to our parents: Margaret and Dennis Bray, Shelly and Matt Connor, Janelle and John Cooney, Sue and Peter Hutchinson, Taylor and Mark King, and Renea and Ron Walton.

CONTENTS

Acknowledgments

In doing this research, we have relied on the work of many people, including history students who wrote informative blogs as part of their coursework in the college archives. But more importantly, we heavily consulted the works of Jack Lane, Lorrie Kyle, and Wenxian Zhang. Their expertise and publications have proved crucial to our writing.

We must also thank Scott Cook for taking the time to photograph the last two images in the book, Alison Reeve for managing our budget, and Chris Fuse and James Patrone for supporting us in the Rollins Student-Faculty Collaborative Research program during the summer of 2024.

Furthermore, this project would not have been possible financially without the help of the Rollins College Student-Faculty Collaborative Research Fund, the John Hauck Foundation, the Edward W. and Stella C. Van Houten Memorial Fund, the Office of the Dean of Faculty at Rollins College, and the Rollins President's Office. Finally, we appreciate all the staff in Olin Library for being so welcoming during our summer of intensive work, especially Liriam Tobar and Wenxian Zhang, who made us feel at home in the college archives and helped us ensure the accuracy of our work.

Unless otherwise noted, all images included in the text are courtesy of Rollins College Archives and Special Collections.

INTRODUCTION

Rollins College is a private, liberal arts college in Central Florida with roughly 3,000 undergraduate and graduate students and more than 600 faculty and staff. Nestled between idyllic Lake Virginia and the historic Southern town of Winter Park, Rollins was founded by New England Congregationalists in 1885 as the first recognized, coeducational, post-secondary institution of higher learning in the state of Florida.

The town of Winter Park was established by wealthy Northern industrialists and incorporated around the same time as the college's founding. Growth in Florida tourism during and after the turn of the century transformed the small town of Winter Park into a popular vacation destination with luxury amenities like lakefront hotels, golf courses, and a thriving main street. As a planned and intentionally segregated community, Black laborers supported infrastructure building and service industries enjoyed by seasonal New England vacationers and contributed to the college's labor force as well.

In its early years, the college struggled to establish itself as an institution of higher learning within the unforgiving environment of rural Florida. Despite the introduction of the South Florida Railroad line in 1882, the journey from the more populated parts of the eastern seaboard to Central Florida could take days, and life in 19th-century Florida was hot and isolated, to say the least. Given these conditions and that few individuals had enough education to qualify for college in those years, the college found it difficult to attract students. As such, Rollins's first students and faculty included both women and men to gain as many students as possible. For the same reason, Rollins admitted high school–age students into a program called "Rollins Academy" to prepare young learners for the rigors of a Rollins College classroom. Other early challenges included the college's first endowment being destroyed by a freeze of the orange groves, yellow fever and measles epidemics, and fires destroying several of the campus's buildings. Many of Rollins's first students also struggled financially and paid part of their tuition with goods such as produce, turkeys, and molasses.

Financial uncertainty continued for several decades, only improving toward the beginning of the long presidency of Hamilton Holt in 1925. Holt was a renowned journalist, political actor, social justice advocate, and a leader in the world peace movement. It was his presidency—his unorthodox approach to higher education, cosmopolitan values, and celebrity status—that put Rollins on the map and set the college on the course for success.

Against the landscape of early-20th-century race relations in the South, the remarkably progressive social values of Holt—a founding member of the NAACP—and the many faculty he hired made Rollins rather unique. For example, with Holt's support, several members of the English department mentored African American writer Zora Neale Hurston and allowed her original play *From Sun to Sun* to be performed on campus in an unsegregated setting in 1933. Even more boldly, in 1949, Holt went against the desires of the board of trustees and awarded Mary McLeod Bethune, a recognized leader in Black

education, the first honorary degree given to an African American woman in the United States. Despite these early moments of liberalism, Rollins did not desegregate its student body until 1964, and the first African American students did not graduate from the college until 1970.

Rollins did see some diversification of the student body as early as the 1890s due to the presence of several international students from countries like Japan, China, Cuba, and various parts of Europe. Today, with a large undergraduate international business major and a highly popular study abroad program, Rollins students continue to enjoy a global educational experience. In addition, since the post–World War II years, Rollins has seen an increase in the number of nontraditional and commuter students on campus, further diversifying the campus experience. With the establishment of the Institute of General Studies in 1960, later renamed the School of Continuing Education in 1973, Rollins began educating GIs and other evening students for the first time. With the founding of the Crummer Graduate School of Business in 1966 and the establishment of the Hamilton Holt School in 1987, Rollins further entrenched itself as a leader in adult learning.

Whether international, residential, or commuter, Rollins students throughout history enjoyed the college's lakeside location, and many participated in a strong tradition of active water sports like water skiing and crew and outdoor recreation via boat, canoe, or kayak. Visits to nearby springs and picnics in the Florida sun quickly became a hallmark of the Rollins student experience. Likewise, since the 1930s, Rollins students have cherished the campus's lovely Spanish Mediterranean–style architecture and impressive landscaping. On several occasions, Rollins was voted one of the most beautiful campuses in the nation, and current visitors comment on its attractive buildings and scenery. Rollins students have excelled in both sports and the arts for generations. For example, 1940s female tennis legends Nancy Morrison, Shirley Fry, and Connie Clifton were among Rollins's first star athletes, outperforming their male counterparts. Additionally, famous performers Fred Rogers, Dana Ivey, and Anthony Perkins were all once Rollins students.

In the classroom, Rollins has always leaned toward innovation. While traditional classical curriculum dominated the early catalog, major changes in learning standards and teaching practices were introduced once President Holt arrived. For instance, the Conference Plan of study, introduced by Dr. Edwin Grover (nicknamed "Professor of Books") in 1926, offered students the opportunity to discuss course subject matter with peers and faculty as part of their classroom learning process. Students sat at a large oval table that fostered conversation and debate rather than a traditional lecture approach. Soon after, in 1931, Rollins hosted a Curriculum Conference with learning expert John Dewey, who led educators in a discussion of core curricula, general education, and the overall purpose of a bachelor's degree. The resulting recommendations emphasized "Individualization in Education" and were immediately implemented the following year. These foundational pedagogical concepts—particularly the idea of individualized learning in an intimate classroom environment—remain a signature component of the Rollins classroom experience today.

Beyond the classroom, Rollins students had many social engagements. Whether in sports, clubs, Greek life gatherings, or volunteer work, Rollins alumni recall the camaraderie and community of their fellow classmates when they look back at their time on campus. One particularly cherished tradition for all of campus is Fox Day. Established by Rollins's 10th president, Hugh McKean, in 1956, Fox Day is a day in the spring when the president cancels all classes, surprising undergraduates with a day off. Most students travel to the nearby beaches or attend any number of entertaining campus festivities on Fox Day. Other beloved and entertaining campus events enjoyed by Rollins students over the years included the Holt Animated Magazine variety show, the Winter Park Institute speaker series, and more recently, Lip Sync—a student-run karaoke dance competition.

In the spirit of student-faculty collaboration, this book aims to provide an authentic, well-researched, student-centered history of Rollins. The authors, two Rollins faculty and four Rollins history majors, offer an uncensored and holistic reflection of the college's past, as informed by the college archives, for the benefit of current and future researchers.

One

THE FOUNDING

The mother of Rollins College, Lucy Cross, was born in New York in 1839. Her training at Oberlin College prepared her for teaching at several schools in the Northeast before an 1879 health-related move to Daytona Beach, Florida. Finding schooling in frontier Florida lacking, she opened the Daytona Institute in 1880. At the same time, she started working with her pastor, Rev. C.M. Bingham, to establish a permanent college. In 1884, they requested help from the Congregational Association. The church, which had helped establish other institutions such as Yale and Dartmouth, agreed to sponsor a school and asked Cross and Bingham to determine a suitable location. Five Florida cities—Jacksonville, Daytona, Orange City, Mount Dora, and Winter Park—submitted bids to host the new school, and thanks to substantial pledges of land and money, the grant was awarded to Winter Park.

Founded in 1885, Rollins College was named for donor Alonzo Rollins. Rollins, a Chicago businessman, had purchased land in Winter Park, where he sojourned annually for his health. By the early 1880s, Winter Park was a growing tourist spot, boasting beautiful lake vistas and a temperate climate that attracted affluent Northerners. In its early years, the college remained affiliated with the Congregational Church. Edward P. Hooker, who served as the college's first president (1885–1892), was an active member of the local church and aimed to ingrain Christian values in the institution's curriculum, emphasizing moral behavior and actions for students. Grounded in the classical ideals, Rollins College was the first higher-learning institution in Florida, setting the standard for future liberal arts colleges in the South. With few buildings and little infrastructure on campus, the college's humble beginnings allowed for about 60 students in its first class. To increase revenue, the college also enrolled adolescent students through the preparatory Rollins Academy. Many of these first students relished the Florida environment, enjoying picnics, boating endeavors, and physical fitness activities outside.

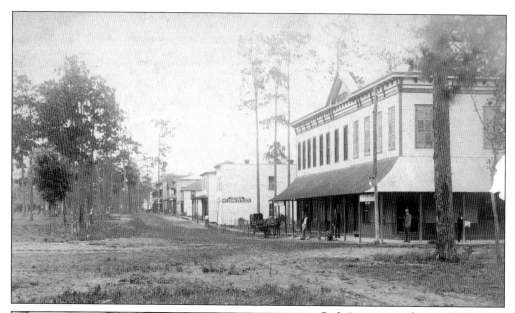

Park Avenue, seen here in 1888, three years after the founding of Rollins College, was home to various shops frequented by the town's affluent residents. The first building on Park Avenue was Henkel Block, which contained five stores and Dr. Miller A. Henkel's medical office. A revered leader of the small city, Dr. Henkel gave back to his community during his three terms as mayor of Winter Park.

A cofounder of Winter Park, Loring A. Chase (pictured on the right) moved to the South to seek a warmer climate following various bouts of illness. After falling in love with the quaint city just north of Orlando, Chase devoted the rest of his life to developing and establishing Winter Park, including Rollins College, making it a desirable location for Northern tourists and future generations.

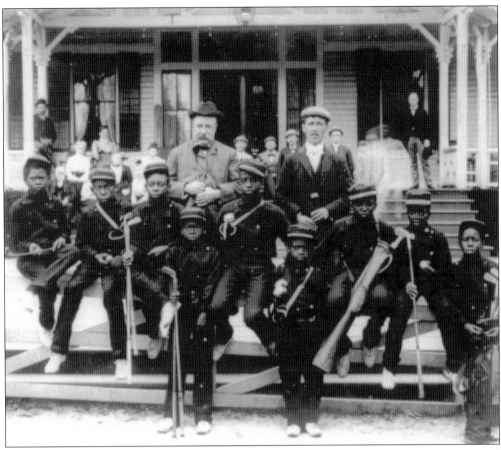

The city of Winter Park's initial agricultural economy was augmented by tourism, as the town attracted many Northerners during the winter months. The local Black population served as the primary workforce at Rollins College in addition to a variety of hotels, small businesses, and private homes. Winter Park was racially segregated. African Americans resided on the west side in a community named Hannibal Square and were subject to much lower socioeconomic conditions compared to their White neighbors east of the railroad tracks. Hannibal Square offered its residents a vibrant community built around many churches that were constructed in the late 19th century, an early elementary school, and later, the Colored Day Nursery, which survives to this day.

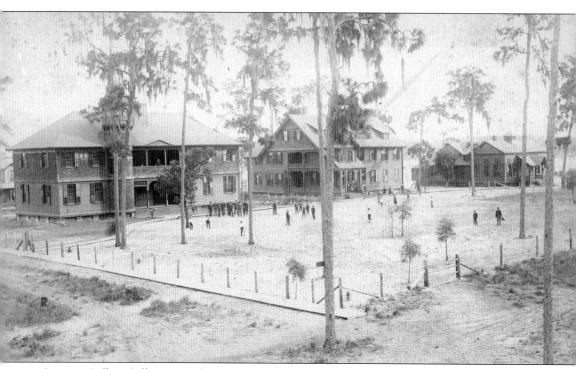

In 1885, Rollins College, a coeducational institution, opened its doors to its first group of students. The founders and first donors of the institution were Northeasterners who longed to build a traditional Northern college with an emphasis on a classical liberal arts curriculum while also benefiting from the Florida weather. The campus, seen here in 1888, was composed of three main buildings: (from left to right) Knowles Hall, Pinehurst Cottage, and the Dining Hall. Legend says that the original fence around the campus perimeter was constructed to keep out local grazing cows. Built along a horseshoe-shaped path, the first buildings of the college were constructed in a New England style, paying homage to the classical ideals the founders hoped to instill in the students. The early student body outstripped the available space, so some of the first classes were taught at the local Congregationalist church, which also provided much of the school's early funding.

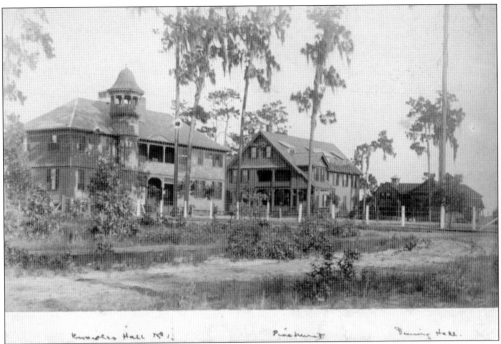

Knowles Hall (pictured on the left) was one of the most frequented buildings by students and staff. Named after Francis B. Knowles, the first Knowles Hall was built in 1886 and housed classrooms, recitation rooms, the chapel, and the first college library. Knowles Hall burned down on December 2, 1909, devastating the campus. With the loss of space, equipment, and the campus bell, the Rollins community hurried to rebuild. Knowles Hall II was built with brick, making it better equipped with fire protection. The new hall became home to the departments of biology, botany, chemistry, and physics, including recitation rooms and laboratories, as well as an auditorium serving as the campus chapel once again. Pinehurst Cottage (featured at center) survives to this day, making it the only original building on campus.

Built in 1886, the first Dining Hall was contributed by Rollins trustee Francis B. Knowles. Nicknamed "the Beanery," it was used as a cafeteria and housed the physics and chemistry laboratories. Being the only place to eat on campus, it was loved as a place to gather and hated by students because of its lackluster food. In 1918, the original Dining Hall burned to the ground, and a new building opened the following year.

The first library on campus, Carnegie Hall, was built using financial contributions from the Andrew Carnegie Foundation. Most of the nearly 1,800 Carnegie libraries were built in small towns around the nation, with just 109 on college campuses. Rollins's Carnegie Hall has been repurposed over the years to serve the needs of the college. Currently, the building is home to the English department, student services, registrar office, and financial aid.

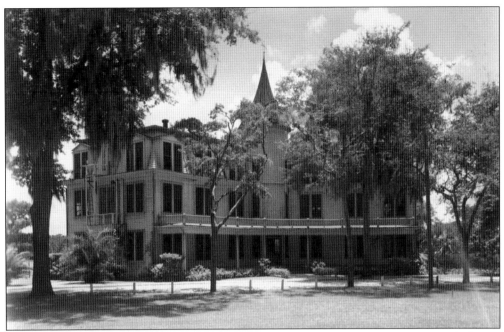

In 1891, Cloverleaf Cottage was built as the Women's Residence Hall. At the time, it was the largest and most expensive building on campus. The building's floor plan was shaped like a clover leaf, with an iconic cylindrical tower and 56 rooms. The local *Winter Park Advocate* magazine awarded it the title of the most beautiful and largest building in Winter Park in 1892. In 1895, the *Sandspur* proposed the name "Cloverleaf" to recognize the building's shape and its "desirability as a residence." Throughout its time on campus, Cloverleaf was strictly used as the girls' dorm and to house the Alpha Phi sorority. This was unlike other buildings' functions, which would adjust to the needs of the college. By midcentury, the once beautiful building had fallen into disrepair, and it was finally demolished in 1969.

6:00 A.M. and

"Meet Me at the Old Family Tree"

These are the passwords for the Annual

ALUNNI-SENIOR BREAKFAST, JUNE 5

Isabel Green is in charge of arrangements. Enough for that.

Dickie Dickson is in charge of entertainment. Enough for that too.

The same place, the Old Family Tree across Lake Virginia from the campus. Send your reservation ($1) to Fred Ward.

You are also invited to attend
(a) The 46th Commencement—10 a.m., and
(b) The Senior Luncheon at 1:00 p.m.

The Family Tree, also known as the "Breakfast Tree," stood tall across Lake Virginia in a quaint spot off-campus. This grand tree served as the location for picnics, dinners, and sunrise breakfast for students and faculty alike. The Family Tree hosted the traditional alumni-senior breakfast, an integral part of commencement festivities in which the campus community came together to cook bacon and eggs over a campfire for the graduating class. Though it is unclear exactly when the alumni-senior breakfasts tradition began or ended, it continued well into the 20th century. As seen on the postcard above, seniors would be invited to their breakfast through a collection of riddles and passwords they had to solve. This cherished tradition emphasized the Rollins approach of embracing local nature and neighborhood. It also highlights the connection to the lake in which generations of students had to demonstrate their swimming competency before they could graduate.

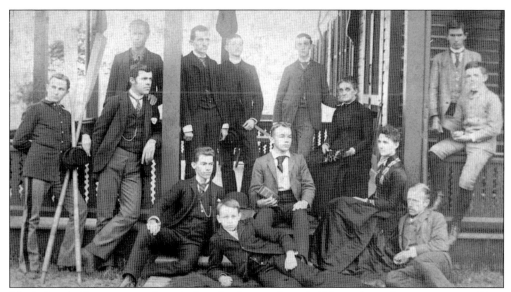

The Lakeside Cottage opened in 1886 as the first residence hall for male students on campus. Here, in 1889–1890, the residents and their matrons pose for a photograph commemorating their time spent in the dormitory. Among this group of students is Frederick Lewton (second from left, leaning on the porch), who left Rollins in 1890. Later in his life, Lewton rejoined the Rollins family as a part-time archivist for the college.

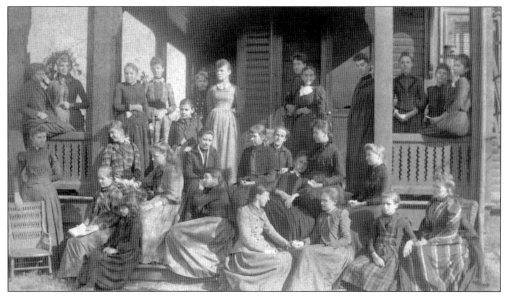

Designated a women's dormitory upon its construction in 1886, Pinehurst Cottage earned its name from its original location near a stand of pines. Above, the female residents of Pinehurst Cottage gather on the porch around 1890 for a group photograph. In addition to functioning as a women's residence hall, Pinehurst at different times also housed the library and even more dormitories.

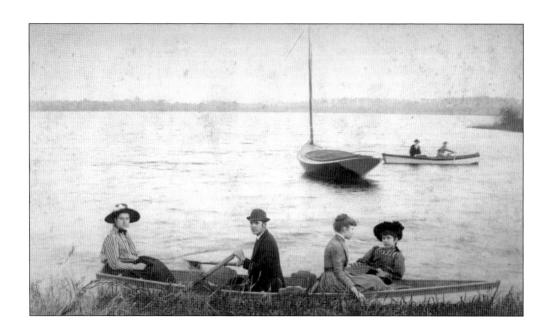

Oftentimes, students would beat the Florida heat by taking out boats and rowing on the local lakes. Being built upon Lake Virginia, Rollins had easy access to the string of canals connecting Lakes Maitland, Osceola, Mizell, and Virginia. These canals were dug in the 1890s to move lumber and turpentine to railheads and then transport them to the wider world. Rollins students, however, used them for leisure and relaxation. Boating trips along the lakes and canals became an essential part of cooling off. Lake Virginia has continued to play a pivotal part in the life of Rollins, with a beach at Dinky Dock Park, a boathouse, and a water ski ramp providing aquatic entertainment for students. Likewise, a long-standing boat tour takes visitors and parents through the picturesque Florida landscape.

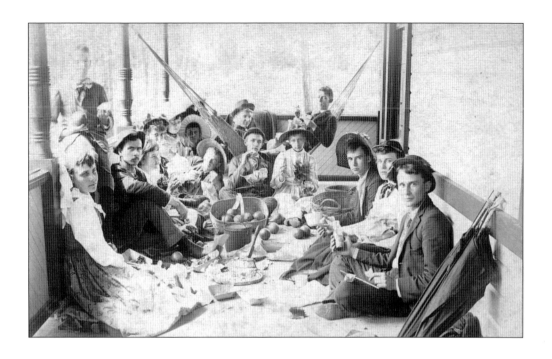

During the early days at Rollins, students would often enjoy a picnic outside with their peers to take advantage of the warm Florida climate. Unlike other recreational activities on campus, picnics were allowed to be coeducational and did not require a chaperone. In the first photograph, students enjoy an array of fruits and hearty sandwiches. Men and women appear relaxed and sit closely together on the floor, while some students sway in hammocks in the background. The second image, from 1890, shows an outside picnic among the saw palmettos (different from the state tree, the sabal palmetto). Being able to separate from the stresses of the classroom allowed students to bond and form lifelong relationships with one another.

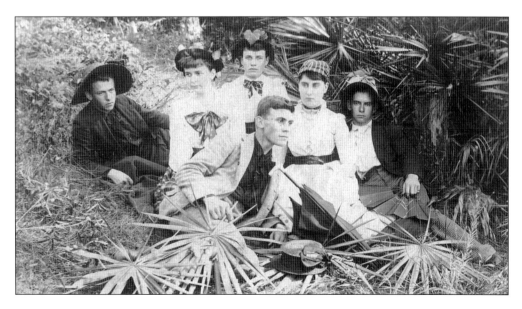

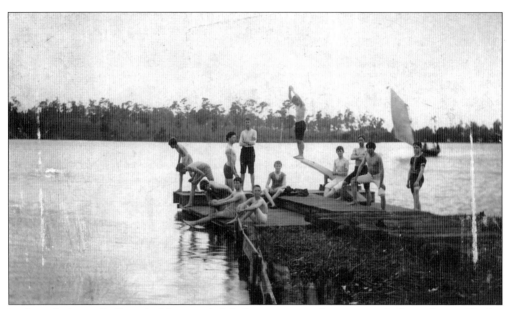

In the early days at Rollins, the lake provided the largest source of entertainment for students. Whether used for boating, rowing, or just taking a refreshing dip with friends, Lake Virginia never disappointed. As seen above in 1895, a group of boys enjoys diving off a makeshift diving board in the lake.

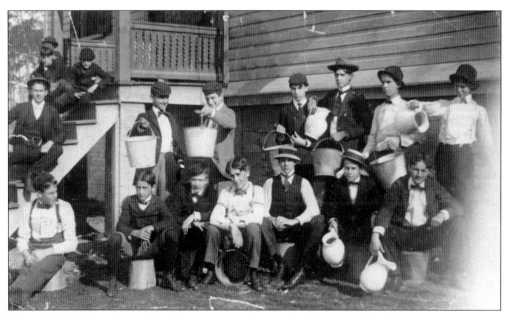

Winter Park did not have a fire department until 1900. As the original buildings on campus were constructed of wood, fires were a serious and common threat. Thus, Rollins College created a bucket fire brigade. Groups of men would assist in putting out various fires on campus, passing buckets of water down a line to extinguish the flames.

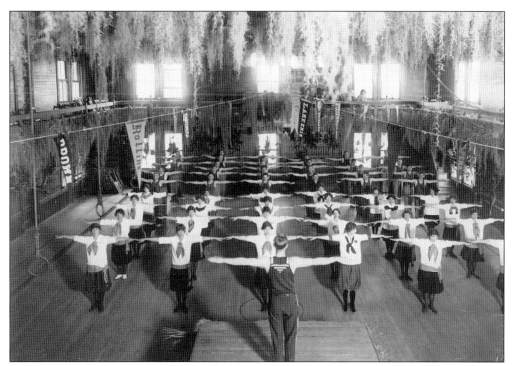

Many early students attended Rollins College to reap the supposed benefits of the Florida climate. To further these health benefits, the Rollins curriculum required athletic classes. Various group classes, such as running and jumping, gymnastics, and fencing were held in the Lyman gymnasium and were mandatory for male and female students alike.

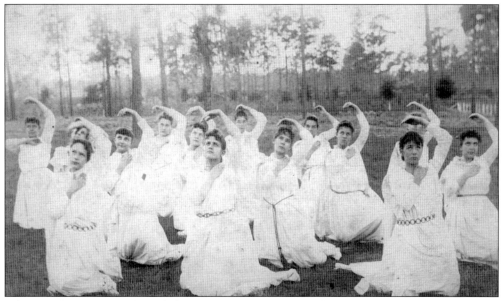

Life certainly imitated art through the Greek Posture gymnastics classes. Perhaps designed as an homage to the college's roots in classical education and ideology, students would regularly participate in the Greek Posture class as a part of their physical education requirement. The classes were instructed by the fencing teacher, Grace Livingston, and were offered to both men and women.

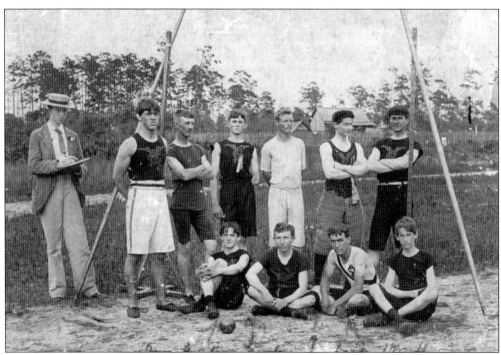

The track and field team, as seen in 1891, included one Rex Beach (second from left, with his arms behind his back). Beach enjoyed infamy for breaking college rules. These included smoking on campus, going on more than one date per week, and staying out past curfew. Despite leaving Rollins without a degree to pursue legal studies in Chicago, the college awarded him honorary bachelor's and doctorate degrees when he later became a well-known playwright and novelist.

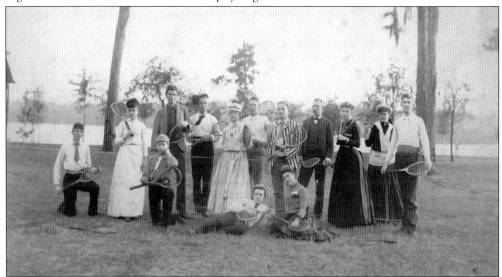

Health and fitness were an important aspect of the Rollins experience. Students gathered to partake in their favorite sports, like tennis. The coed Tennis Club, as seen here in 1889 or 1890, highlighted camaraderie among students. Many of the students pictured appear younger than the average college student, likely members of the Rollins Academy. Rollins enrolled precollegiate students through 1923 to help students prepare academically and increase its revenue.

Two

ACADEMICS

Since its beginning, Rollins College has offered a wide variety of courses suitable for every student. However, the foci of academic study have changed considerably over the years. Upon its founding in 1885, Rollins admission requirements included knowledge of Latin and Greek as well as a foundation in classical history. By 2015, national educational standards had become more quantified, and potential students were assessed based on their GPAs, SATs, ACTs, and personal essays.

Despite the changes over time, Rollins's commitment to a well-rounded education has remained an integral part of its mission. The Conference Plan, introduced in 1931, provided an interactive education that remains in use today. Students choose courses of interest in addition to their selected major, creating a personalized schedule. Students also receive mentorship from their professors in small and intimate classroom settings. This unique approach to learning extends far beyond the classroom, as all Rollins students are encouraged to participate in study abroad. Whether through short field study or a semester abroad, more than 70 percent of students today study internationally. Additionally, Rollins offers opportunities for students to do original research with faculty, present at conferences, and publish in academic spaces.

Such intensive education is expensive. For many students, attending Rollins College would be impossible without financial aid. Rollins's scholarships range from $5,000 annually to the prestigious Cornell Scholarship (now named the Alfond), which completely covers tuition, fees, and room and board. In addition to academic and athletic scholarships, many departments award students for their achievements within their majors, and in 2013, Rollins started offering Bonner Scholarships for students who excel in community service.

Throughout its history, Rollins College has remained true to its vision of a liberal arts education. Consequently, its fields of study have expanded to include STEM programs, a growing business major, and more. Rollins added schooling for nontraditional students in 1951 and a graduate school of business in 1957. However, no matter their chosen major, all students are encouraged to enroll in courses outside of their interests to think critically and learn from a broad range of perspectives.

Before students begin their academic journey at Rollins College, the campus community gathers in Knowles Chapel for the Convocation ceremony, traditionally scheduled for the morning of the first day of classes. The college president invites faculty to join in welcoming the new first-year students and celebrate the beginning of the academic year.

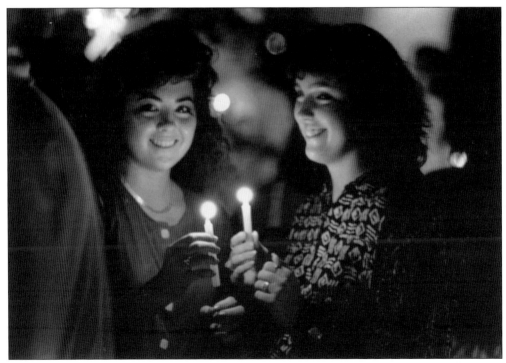

Rollins first-year students also participate in Candlewish, where they vow to spread the light of Rollins's education with their peers. Gathering in the evening in Knowles Chapel, students carry candlesticks and think about their goals for their next four years at Rollins. Candlewish brings the Rollins motto of *Fiat lux*, which translates to "let there be light," to life, marking an important transition for students.

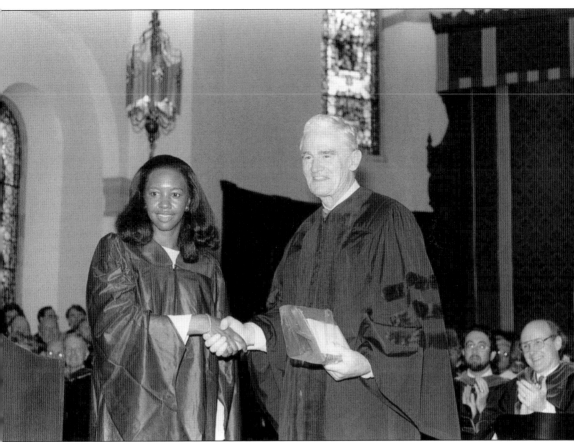

Rollins College offers its students a wide array of scholarships, both academic and nonacademic. One of the most prestigious awards a Rollins student can achieve is the Donald J. Cram Award. Cram, class of 1941, attended Rollins on a National Honorary Scholarship and worked diligently with the chemistry department while also being an active member in various societies and clubs. Cram grew up in an immigrant family and suffered immense financial hardship after the passing of his father when he was three years old. In 1955, Cram won a Guggenheim Fellowship, which was followed by his election to the National Academy of Sciences in 1961. For his outstanding work in organic chemistry, the Rollins alumnus received a Nobel Prize in Chemistry in 1987. Rollins dedicates a scholarship award in Cram's name for majors in computer science, mathematics, physics, or chemistry. Up to 10 students are awarded annually, and the winners receive $5,000 in aid.

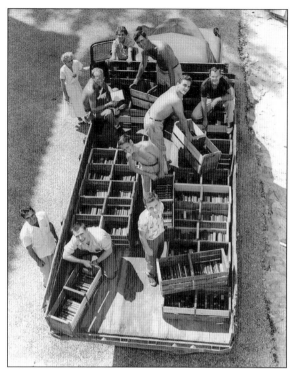

As the college prepared to move the campus library from Carnegie Hall to Mills Memorial Library in 1951, students rallied together to help transport books between buildings. The Mills Library offered more than just a collection of 150,000 books. Along with extensive study spaces, it also provided designated areas for a photography lab, music rooms, the WPRK radio station, and a home for the college archives. In 1985, thirty-four years later, the library moved again, along with a cadre of professional librarians, this time to Olin Library, with its iconic tower overlooking Lake Virginia. This library houses study spaces, tutoring help, accessibility services, and informational technology, making it a hub for student research and study.

To make the most of the Florida sunshine, some professors opt to conduct their classes outside. Whether sitting under a tree, as demonstrated here by Prof. Herman Harris's class from the late 1920s, or simply a student study group gathering in the fresh air, an education outdoors has been one of Rollins College's major selling points. Ranked by the *Princeton Review* and others as one of the nation's most beautiful college campuses, Rollins boasts a tropical climate, Spanish mission architecture, and lush foliage. In many ways, the surrounding nature is embedded into the college's educational mission. Pres. Hamilton Holt (1925–1949) made it a goal during his administration for Rollins to be known as the "Open Air College of America."

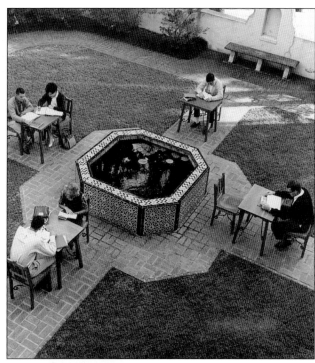

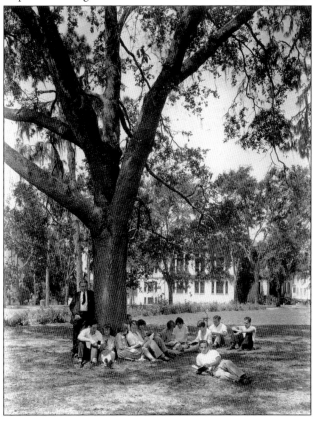

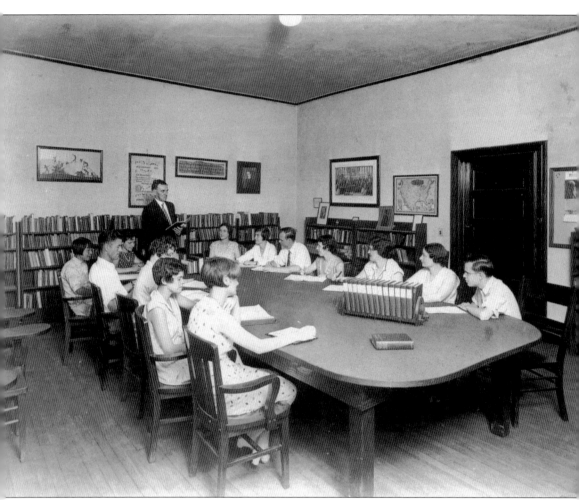

One of President Holt's most notable accomplishments was the implementation of the Conference Plan style of learning. With an emphasis on small group collaboration and teacher-student mentorship, the Conference Plan became one of Rollins's most defining features as a liberal arts institution. During the late 1920s, "Professor of Books" Edwin Grover asked the campus carpenter to build a large oval table (14 feet by 6 feet), which he surrounded with 20 comfortable oak armchairs. He aimed to avoid the formality of the conventional classroom and secure closer and friendlier contact with the students. The walls of the room were decorated with a score of artifacts and pictures such as framed pages of old books, block prints, lithographs, autographed portraits, and letters. Additionally, more than a thousand books from every literary field filled the shelves, providing both the essential curriculum and a special scholarly decorum. This classroom atmosphere and collaborative study method is still a cherished learning style at Rollins today.

With a keen eye for design and technique, Rollins's art department allows students to explore their artistic passions while also gaining transferable professional skills, such as communication and collaboration. The art department offers its students ample opportunities for research and studio art production, as well as bringing in renowned artists and sculptors to work with students.

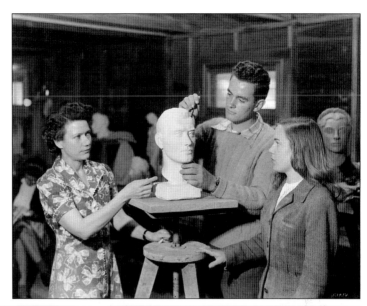

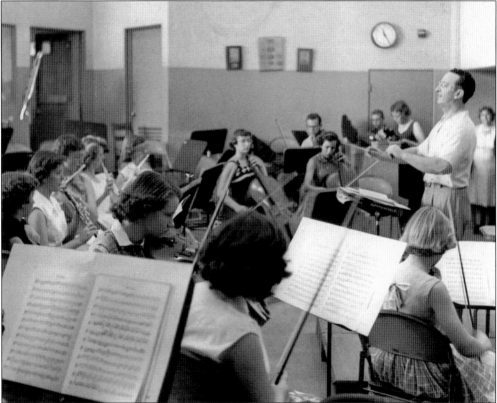

Through applied learning, ensemble participation, and research in music theory, the department of music is one of the college's most distinguished programs. Students are encouraged to explore music both inside and outside of the classroom, with opportunities for performances in both areas. Seen here in one of his 1950s music classes, legendary professor Alphonse Carlo guides his class in an orchestral piece, demonstrating the hands-on approach to musical practice.

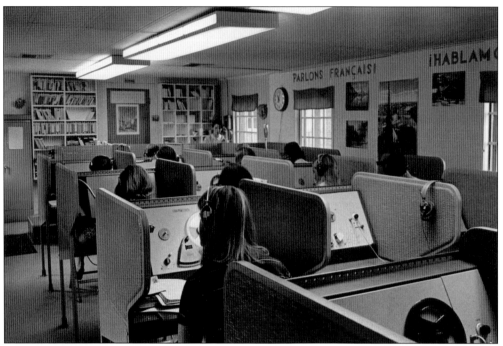

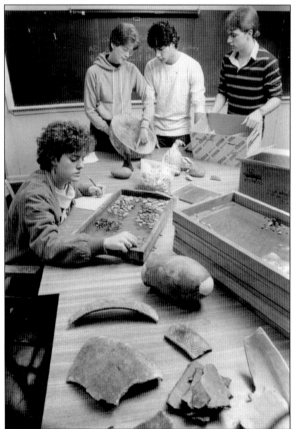

Part of Rollins's mission is to prepare students for "global citizenship and responsible leadership." Therefore, the college requires every student to take foreign language courses. The department of global languages and cultures inspires students to appreciate cultural diversity at home and abroad. The first step lies in the classroom, as seen here in 1970, where students gain essential intercultural skills and practice what is needed to succeed in today's globalized society.

With a hands-on approach to learning, the department of anthropology allows students to investigate archaeological wonders and learn the steps necessary for preserving their artifactual findings, as demonstrated in this 1970–1980 photograph. Students are taught the strategies necessary to cross-culturally examine human behavior in a holistic way based on their physical findings. These interpretative skills are becoming increasingly relevant in the multicultural society of today.

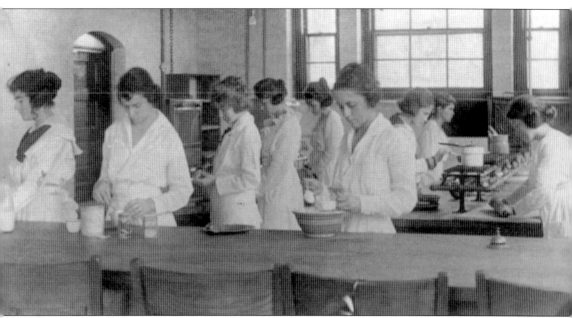

Like most colleges in the early 20th century, Rollins College offered home economics as part of the curriculum. Educator, historian, and community activist Lucy Worthington Blackman established the domestic science department in 1902, the first of its kind in Florida. Students took classes on sewing, cooking, and according to Blackman, a range of other classes "wholly compatible with, or even essential to, a girl's education." Known as the college's First Lady from 1902 to 1915, Blackman taught these classes herself for more than two years until the school found funding for a trained teacher and supporting equipment. The program was offered to students until 1924. Blackman worked tirelessly to press for educational improvements and social reform that recognized the influence of women in society. She was an active clubwoman at the local, state, and national levels and authored the book *The Women of Florida*.

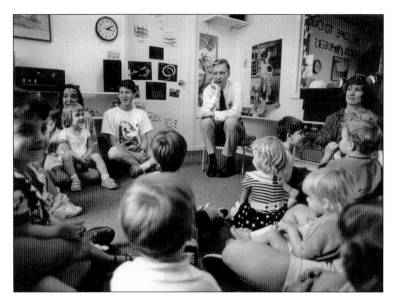

Established in 1975, the Hume House Child Development Center (CDC) allows for students to interact with children and conduct research in the psychology and education departments. In this photograph, the beloved alum Fred Rogers and his wife, Joanne, visit the CDC, teaching children the important qualities of being a loving neighbor.

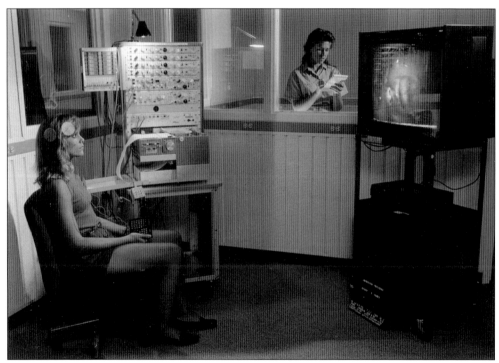

In a field like psychology, putting skills into practice is essential for mastering the discipline. Through independent studies and research projects, psychology majors gain valuable experience and knowledge for their future careers. In this photograph taken in the Johnson Center for Psychology on campus, students had access to equipment such as video monitoring, polygraph recording machines, and two-way glass to conduct their experiments.

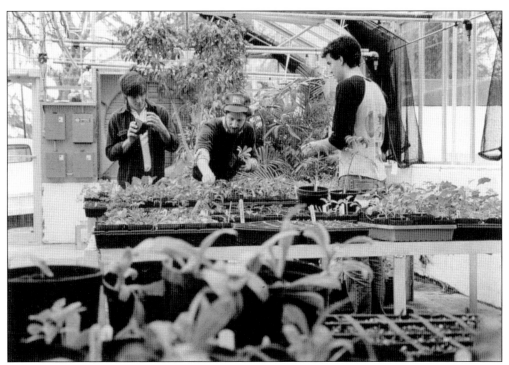

The interdisciplinary approach of the environmental studies department allows students to engage with a wide range of economic, geographical, and political perspectives. The Florida climate and diverse biosphere offers a natural laboratory for students to conduct research and visit sites like the Everglades and local springs. As seen in this class led by Dr. Barry Allen, the campus greenhouse is a valuable resource for conducting research and observations.

The department of biology enables its students to think critically about biological processes and learn how to communicate their findings in oral and written formats. Biology professors allow students to interact with a variety of experiences in the classroom, laboratory, and field settings. In this photograph, a student experiments with various chemicals as he engages in laboratory research.

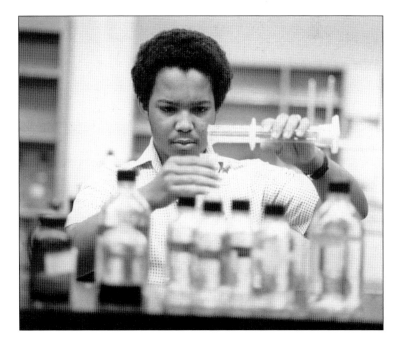

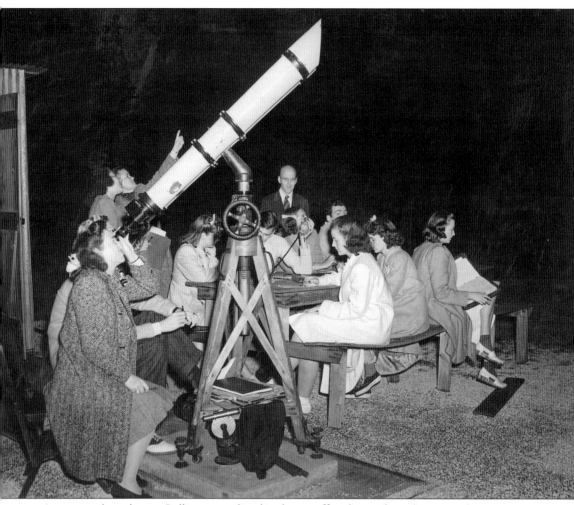

As many male students at Rollins were enlisted in the war effort during the 1940s, women's participation in typically male-dominated fields of study such as science increased. Yet there was still a sharp decline in the number of science majors during this time. In 1941, a Rollins astronomy class was featured in the *Winter Park Herald* newspaper, captioned, "One Rollins Class That Must Be Held at Night." This after-hours class used a large telescope to observe the stars and planets in the sky. As seen in the photograph, most of the students in this STEM class were women, as well as one of the professors, Dr. Phyllis Hutchings, who is accompanied by Dr. William L. Hutchings. This active participation in class exemplifies the Conference Plan that President Holt established nearly two decades prior. Rollins remains committed to an applied education philosophy, prioritizing practice in conjunction with lectures.

Part of Rollins's commitment to the pragmatic classical curriculum is the inclusion of vocational majors that are infused with a liberal arts ethos. The department of business allows students to choose a concentration in family business, finance, marketing, or supply chain operations. As seen in this photograph, business has a long history at Rollins, encompassing fields of finance, economics, and international business. The business program equips students with the skills necessary for entrepreneurial and innovative thinking. Students can take a multifaceted approach to the ever-changing economic landscape and job market. The department of international business at Rollins offers its students global perspectives on the most pressing economic issues of today, enabling them to succeed in their professional careers. Rooted in a liberal arts foundation, the business programs at Rollins prepare students for the global scope of the business and economic world.

Rollins prides itself on its many opportunities for educational travel within various departments. Here, in 1929, students participate in a field study at New Smyrna Beach led by history professor Dr. A.J. Hanna. The students ponder their surroundings as the professor guides a thoughtful discussion on a visit to an old sugar mill, built in the 1840s, which burned down in 1845.

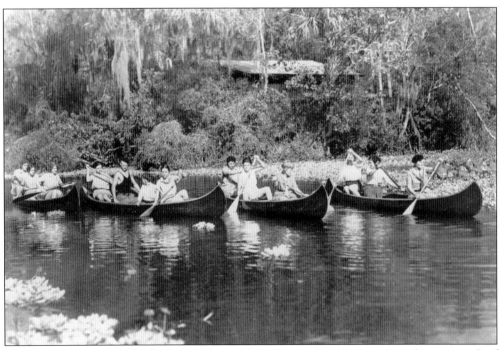

Rollins College owns Shell Island, located in Wekiva Springs State Park, a short distance north of Orlando. Over the past century, Rollins has used this hidden gem as an eccentric outdoor classroom and archaeological excavation site. As seen here in 1939, students take regular trips to Shell Island by canoe to uncover more artifacts to add to the college's growing collection.

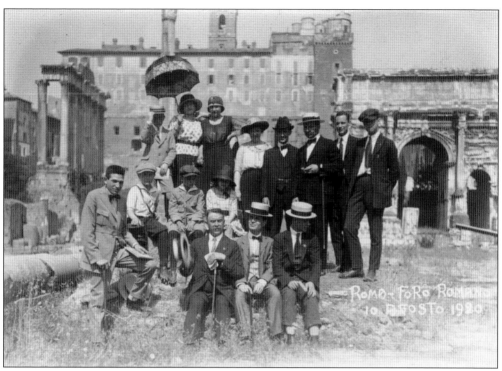

Studying abroad at Rollins has been one of the college's most prominent features, with international adventures dating back a century. In 1920, a group of students visits the Roman Forum. Rollins has kept its connection with Italy strong through international programs and semester programs available through Trinity College Rome and the American University of Rome.

In February 1968, thirty Rollins undergraduates flew to London to study Anglo-American relations and contemporary British theater. The seminars were led by Dr. William G. Fletcher of the history and public affairs departments and Prof. Wilbur Dorsett of the English department. Today, a regular English field study takes students every winter break to the West End to learn from some of the world's best theater.

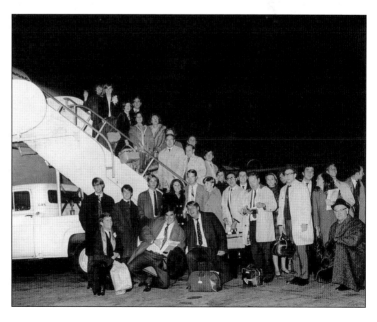

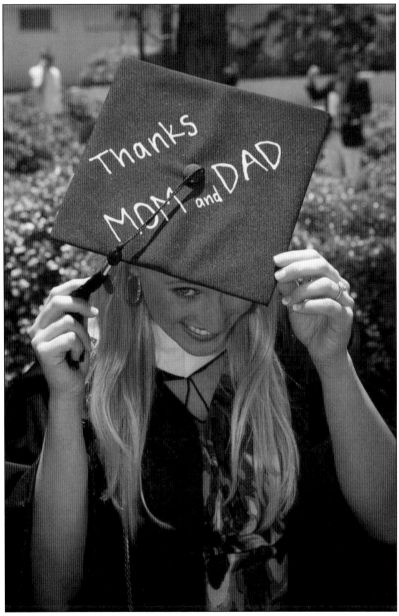

As students end their journey at Rollins, they commence their professional endeavors. Commencement traditions celebrate students' academic achievements and shine a spotlight on their bright futures. For the College of Liberal Arts, graduation ceremonies occur three times throughout the academic year: fall, winter, and spring. Each graduate receives an Artium Baccalaureus degree, and those in the honors program receive an Artium Baccalaureus Honoris degree. Students in the honors program must meet a cumulative 3.33 GPA average to continue and earn their degree. Students can graduate with honors by reaching the following GPA requirements: Cum Laude (with honor), 3.5–3.69; Magna Cum Laude (with great honor), 3.7–3.89; and Summa Cum Laude (with highest honor), 3.9–4.0. At the commencement ceremony, many students choose to decorate their caps to celebrate one of their life's greatest achievements. This student pays thanks to her mom and dad for their help over the past four years.

Three

THE ARTS

Rollins College has a long history of appreciating the visual and expressive arts since its founding in 1885. Students have performed recreationally on campus since the college's inception, exploring their musical and theatrical talents despite the campus lacking dedicated spaces for formal performances. Recreation Hall served as a multipurpose area for both sports and small theater productions, but it was not until the construction of Knowles Memorial Chapel and the Annie Russell Theatre in 1932 that students could fully indulge in creative expression in groups like the Chapel Choir and the Rollins Singers.

Music education at Rollins continued to expand over the years, especially with the construction of Tiedtke Concert Hall in 2006 and the opening of the Tiedtke Theatre & Dance Centre in 2023. Rollins's musical offerings have long extended beyond the classroom experience with the renowned Winter Park Bach Festival. Founded in 1935, the festival's performances are cherished community events. With a theater stage available, theatrical groups also began to flourish. Faculty encouraged students to explore all aspects of production and theater arts, offering a wide array of technical, acting, and directing classes. Equipped with beautiful performance spaces and excellent fine arts educators, it is no wonder that the Rollins stage produced famous alumni such as Anthony Perkins.

The college also has a deep appreciation for the visual arts, having owned many eclectic collections over the years, ranging from natural history objects like seashells to more ornate materials like Tiffany glass. Pres. Hamilton Holt, the longest-serving president at Rollins, welcomed a variety of different collections gifted from various alumni or friends of the college, which were housed and displayed by several campus units, including the library. As the years progressed, Rollins's collection of fine arts grew dramatically under the direction of Pres. Hugh McKean (1951–1969), who was hired originally as a lecturer in the art department. Thanks to McKean, in 1942 the Morse Gallery of Art opened. Later the art museum on campus was renamed the Cornell Fine Arts Museum, and in 2021, it became the Rollins Museum of Art.

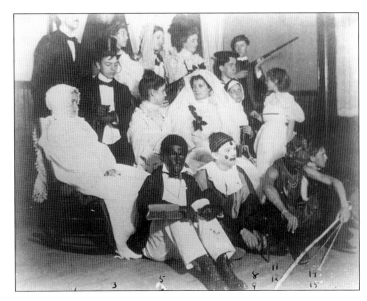

For Christmas in 1899, Rollins students enjoyed a "waxworks" production put on by a traveling troupe who painted themselves to resemble discarded toys. The racial climate at the time made insulting impersonations of different cultures and races, such as blackface, culturally acceptable. Blackface, popular among White vaudeville performers, dehumanized African Americans and perpetuated racist stereotypes.

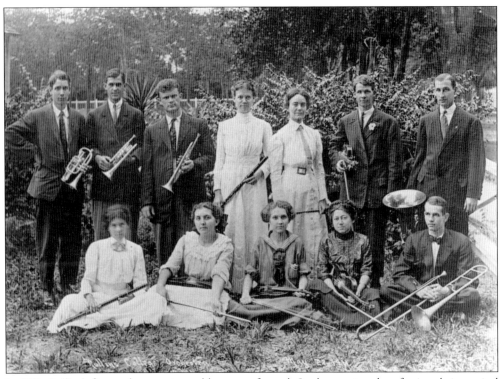

In 1911, Rollins's first orchestra, pictured here, was formed. Students enjoyed perfecting their musical talents among fellow musicians. As time progressed, the college added a variety of beautiful performance spaces, such as the Knowles Memorial Chapel and John M. Tiedtke Hall, to provide students with evocative surroundings to pursue their instrumental talents.

The Knowles Memorial Chapel and the Annie Russell Theatre were both planned and built in 1932. Frances Knowles Warren, daughter of Rollins founder Francis Bangs Knowles, donated $100,000 in memory of her father. The funding allowed for renowned architect Ralph Adams Cram to be hired for the project. Frances, a recipient of an honorary degree in 1935, viewed the building as a personal reflection of her legacy at Rollins. She had strict requirements for how the chapel should be used, instructing that it only be used for spiritual activities that would enrich the student experience. The Annie Russell Theatre was funded by Mary Curtis Bok Zimbalist, a good friend of famed performer Annie Russell. Zimbalist's funding allowed for Miami native and architect Richard Kiehnel to be hired to design the theater. The building's Romanesque style has distinguished it as one of the most beautiful theaters in the country.

Fred Rogers, class of 1951, known nationwide as Mister Rogers, was extensively involved in many extracurricular activities offered at Rollins, spending much time in the Knowles Memorial Chapel. He was an avid member of the chapel staff, After Chapel Club, Chapel Choir, Bach Choir, welcoming committee, intramural swimming, and French Club. He also met his future wife, Sara Joanne Byrd, at Rollins.

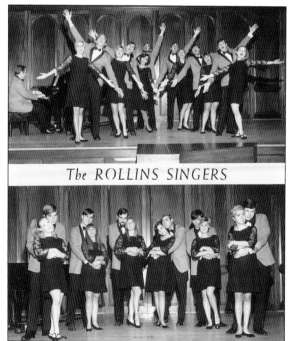

The Rollins Singers, a choral group, frequently performed for audiences on campus and away. In 1969, the group traveled to Europe for an eight-week tour of US military bases, primarily in Germany. The students gave 72 performances, with their audiences ranging from foot soldiers to NATO officials. During their tour, students saw the harsh realities of postwar Germany.

Zora Neale Hurston was a famed Harlem Renaissance playwright and author who grew up in Eatonville, five miles from Rollins. She returned home regularly as an adult to conduct research. On one of her visits, she impressed faculty member Edwin Grover with her draft of *Mules and Men*. Grover, Prof. Robert Wunsch, and President Holt advocated for Hurston's play *From Sun to Sun* to be staged for the first time in Recreation Hall at Rollins in 1933. The play, with an all-Black cast, was open to a White-only audience of faculty and students. The play was well received by attendees, and it became a part of Hurston's impressive canon of African American anthropological and literary works. She was invited back the following year to stage the play *All De Live Long Day*.

ROLLINS COLLEGE

Dramatic Art Department

PRESENTS

ZORA HURSTON

IN HER ALL-NEGRO PRODUCTION
OF AFRO-AMERICAN FOLKLORE

"ALL DE LIVE LONG DAY"

An unique and authentic representation of
real negro folk life by talented
native artists

A RETURN ENGAGEMENT WITH
A NEW PROGRAM AND A NEW CAST

RECREATION HALL, :: ROLLINS COLLEGE
FRIDAY EVENING AT 8:15
JANUARY 5, 1934

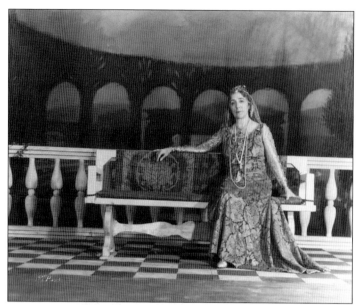

Annie Russell was a British American actress who made an impressive career on stage. Unfortunately, her career was abruptly ended when she became ill during the Spanish flu pandemic of 1918. After moving to Winter Park to retire, her close friend Mary Curtis Bok Zimbalist donated $100,000 toward the construction of the Annie Russell Theatre. Russell christened the new stage with the performance *In the Balcony* in 1932.

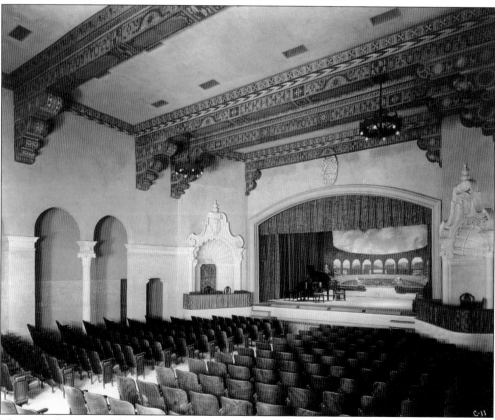

The original interior of the theater followed a traditional Colonial layout with seats being separated by an aisle. Additionally, more patrons could sit in boxes to the left and right of the stage. The theater's original design became outdated by the mid-1970s. Renovations included a new box office and a scene shop that had a specialized workshop for props and costumes.

The Annie Russell Theatre became a hub for students to explore all aspects of performing arts, including backstage production. Students who chose to major in theater arts would learn different aspects of the industry, including radio station operation and techniques, stagecraft, fundamentals of play directing, stage lighting, makeup, and advanced acting. With such courses offered, students soon became well versed in their craft and capable of staging impressive productions. Indeed, in some cases, the stage crew stole the spotlight, as seen here in 1956, when the *Tempest* production team was commended for its work in the *Sandspur* while the students' acting was derided.

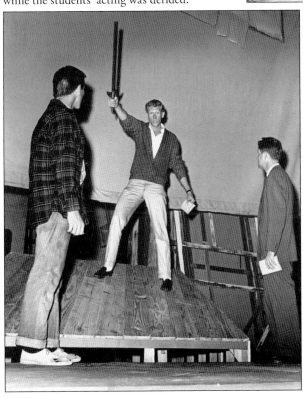

The theater's facilities attracted students from far and wide, including from midwestern states such as Ohio. Here, four Buckeye performers shared an interest in theater production. All were active across campus, participating in different extracurricular activities such as Glee Club or Phi Beta honorary theater fraternity. Students from different social groups were able to collaborate with one another over their shared passion for dramatic arts.

The Rollins Players, a student theatrical group founded in the 1920s, participated in numerous theater productions each year at the Annie Russell Theatre throughout the rest of the 20th century. A version of the organization still exists today. These plays were a source of entertainment for both members of campus and the general public. A ticket subscription package for play attendees helped to fund student scholarships in the performing arts.

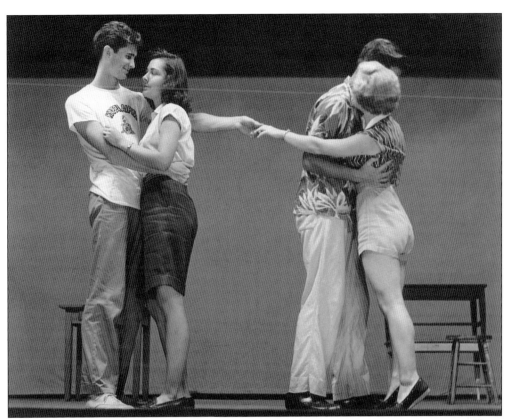

Rollins's theater department produced famous actors such as Anthony "Tony" Perkins and Dana Ivey. Perkins, known for his role in *Psycho*, attended between 1951 and 1953 and appeared in many theater productions, including *Squaring the Circle*. In 1951, he received the Theta Alpha Phi Award for his undeniable talent on stage. Tony Perkins returned to Rollins in 1982 to receive an honorary degree from Pres. Thaddeus Seymour (1978–1990). Ivey's career was also destined for greatness. She majored in theater at Rollins in the early 1960s and then went to study at the London Academy of Music and Art in England. Dana Ivey has appeared in 32 movies, including *Dirty Rotten Scoundrels*, *The Addams Family*, and *Home Alone 2*.

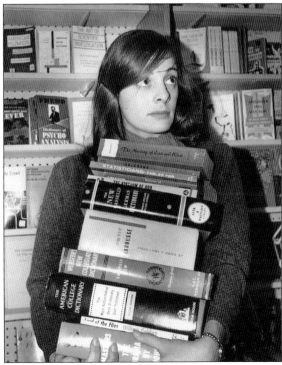

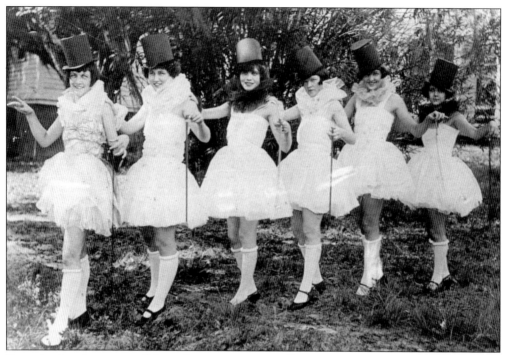

Dance has long been a part of the student experience at Rollins. In 1925, long before Title IX equalized funding for women's sports, the women's athletic department organized a masque dance at the Woman's Club in Winter Park to raise funds. Before the dance, several other entertainments were offered, including songs and theatrical performances. The event was based on the Ziegfeld Follies revue shows that ran in New York City from 1907 to 1931. Dance continued to be important at Rollins, both as a course of study and an extracurricular activity in the day and night school, as this photograph from the Hamilton Holt School in 1996 illustrates. Over time, it became less gendered, with men participating as dancers and instructors.

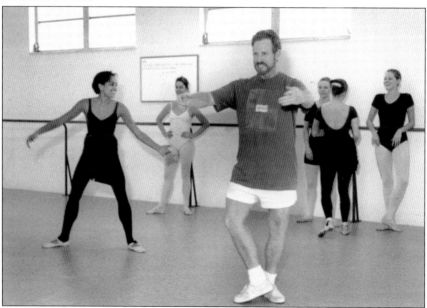

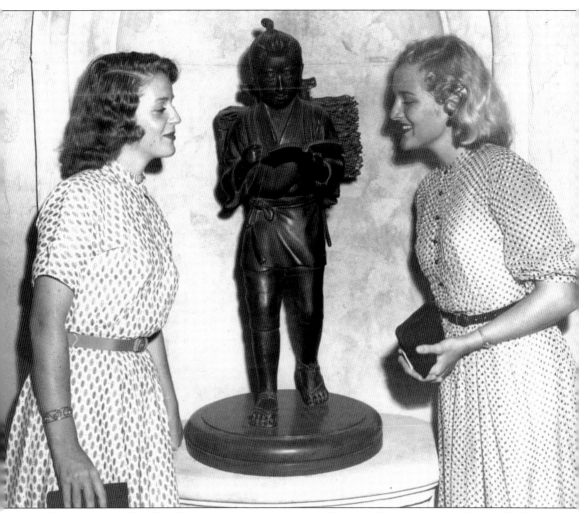

In February 1946, Hamilton Holt accepted a controversial gift from Rollins graduate and former World War II Navy lieutenant commander Clinton C. Nichols. The statue of Ninomiya Kinjiro was seized by American troops who invaded Okinawa and was eventually placed in the college's administration building. Despite the donor's good intentions, it became apparent that the statue was stolen, and its presence at Rollins soon became controversial. In 1983, a student questioned the college's right to own the statue. However, many at the college were reluctant to return it to its rightful home due to Holt's promise to Nichols that it would remain on the campus. Eventually, Pres. Rita Bornstein (1990–2004) was able to persuade the board of trustees to return the statue in commemoration of the 50th anniversary of the end of World War II in 1995.

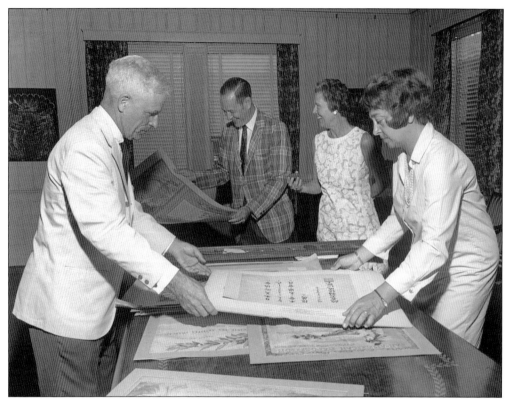

Rollins students have historically benefited from access to an impressive collection of both traditional and contemporary artworks. In part, this is due to the efforts of painter Hugh Ferguson McKean, who was originally hired as a lecturer in the art department. He served as the museum director of the Morse Gallery of Art from 1945 until his death in 1995 and, starting in 1951, as the 10th president of the college. In the 1950s, McKean and his wife, Jeannette, started purchasing works by Louis Comfort Tiffany. Eventually, they accumulated the world's largest collection of Tiffany's decorative arts, including glass, pottery, paintings, and prints. Most of the collection is now housed at the Charles Hosmer Morse Museum of American Art in Winter Park and at the Rollins Museum of Art.

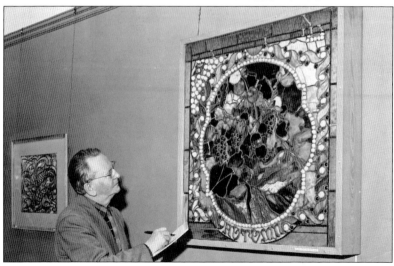

In 1940, Rollins opened a unique shell museum. The purpose-built space was designed to hold what the *Sandspur* described as "the finest shell collection on exhibit in this country and possibly the world." James Beal collected the shells beginning in 1888. His friend Birdsey Maltbie, one of the first mayors of Altamonte Springs, paid for the museum. The building was designed without windows to prevent the shells from fading in the intense Florida sunshine. Visitors could enjoy the shells for a 25¢ admission charge, although Rollins students could visit for free. In 1988, Rollins donated the entire collection to the University of Florida, and the building now houses the environmental studies department.

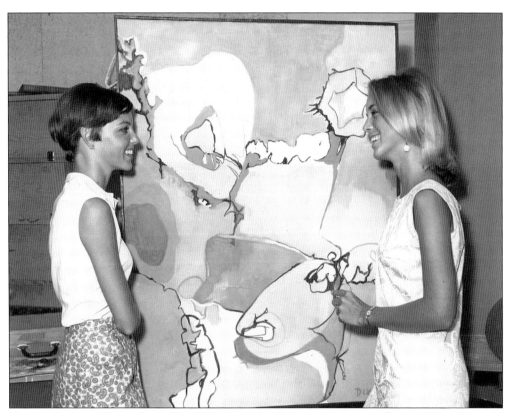

Typical of other colleges, the Rollins Museum of Art houses an eclectic collection that reflects the interests of its students and donors. The result is more than 5,600 works that span everything from ancient to contemporary art. The collection grew under President Holt and was originally housed in buildings across campus until 1942, when the Morse Gallery of Art was opened. The building was expanded in the 1970s to include space for the art and art history departments. Each year, the museum hosts the senior art show, shown here in 1967. Since the early 21st century, the Olin Library has purchased at least one piece of student art per year for display.

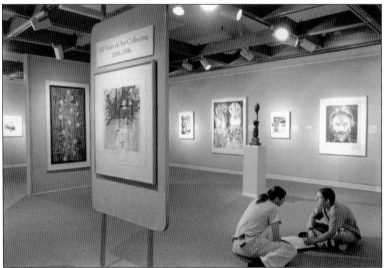

Four

ATHLETICS

With its current status as an NCAA Division II school, Rollins College has placed heavy importance on athletics since its founding in 1885. Many of the earliest athletic activities were centered on Lake Virginia. Boating and swimming provided leisure and exercise for students, complementing their physical education classes. Rollins students enjoyed a variety of other aquatic sports like canoeing, synchronized swimming, and sailing.

When attempting to bring intercollegiate, varsity-level sports to the college, Rollins faced some setbacks. Until the early 1900s, there were hardly any other teams to play against, and there were no eligibility rules. Early sports teams had to play local YMCA or high school teams. It was not until 1917, with the formation of the Florida Collegiate Athletic Association, that Rollins's intercollegiate records began. The association was composed of the University of Florida, Stetson University, Columbia College (Lake City), Southern College (Lakeland), and of course, Rollins. The Rollins football, baseball, and basketball teams were the first to compete in intercollegiate competitions.

Rollins also had its fair share of athletic controversies. From an illegal female coxswain on the Rollins men's crew team to racial discrimination issues in sports like football, sports at Rollins had highs and lows. Most recently, the college honored several of its first Black athletes in the Rollins Sports Hall of Fame to bring awareness to a complicated past. Women athletes in higher education have also been historically underrepresented and underfunded. In the early years at Rollins, men were encouraged to participate in team sports, but women's sports were restricted. By the late 1920s, activities available to women included basketball, baseball, war canoe races, dancing, and access to the iconic diving tower, but it was not until the Title IX Act of 1972 that women's varsity sports were able to flourish at Rollins.

While Rollins prides itself upon its accomplished sports teams, the college also indulges in more friendly and whimsical athletic activities. Over the years, students have regularly participated in intramural competitions and sports like canoe tilting and log rolling.

ROLLINS

The official mascot of Rollins College is the Tar, which stems from World War I, when Lake Virginia housed a naval training center for sailors. The school incorporated the mascot informally in the early 20th century, and it was officially adopted in the 1960s. A student attempt to "Trash the Tar" in the 1990s failed, and Tommy the Tar remains in use today.

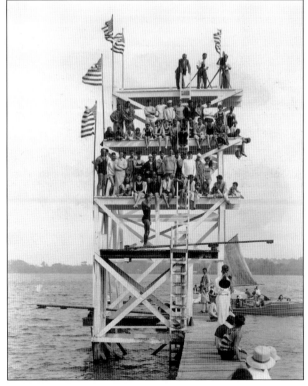

Lake Virginia has been central to the sports life of Rollins since the college's conception. By 1914, a swimming test was mandatory for students, and those who could not swim were instructed to bring water wings. This iconic 32-foot diving tower was a popular spot during the 1920s (despite its questionable structural integrity). It was used for diving competitions, by spectators of aquatic events, and as a hangout for students.

"On the Shores of Lake Virginia" appeared in the 1927 Rollins Songbook. This lighthearted and affectionate tune encapsulates the students' love for learning by the lake. Part of the attraction was that many students hailed (and still do) from the Northeast, so living on a lake that was not frozen for half of the year was a major perk of coming to the Sunshine State.

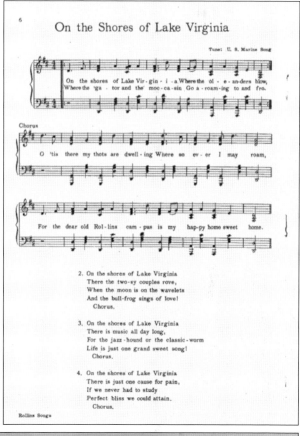

Swimming is one of Rollins's most established sports. In 1922, the men's team won the first-ever intercollegiate swim meet in Florida. In contrast, women at Rollins had to deal with swimming restrictions, including only being allowed to swim in the lake for 20 minutes a day. Nonetheless, over time, Rollins forged a strong team, earning a remarkable collegiate record.

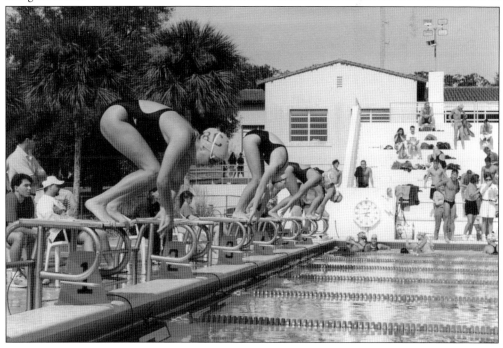

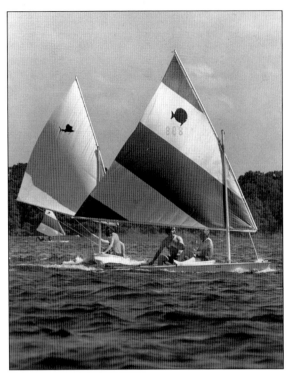

Being situated on Lake Virginia, competitive water sports and leisure activities flourished at Rollins. The college hosted frequent aquatic meets and contests starting in 1894, and sailing races were a key event. By 1920, Rollins had two sailing canoes (named *Tortoise* and *Jackrabbit*) and two sailing launches (named *Kangaroo* and *Tiger*).

Rollins students began skiing on Lake Virginia in 1940, and by 1948, the team took home its first intercollegiate championship. The waterski team is the only team at Rollins that competes in the NCAA Division I; all other sports are Division II. The famous jump ramp that floats on Lake Virginia was built in 1969 and is still in use today. The team can be seen practicing its tricks year-round.

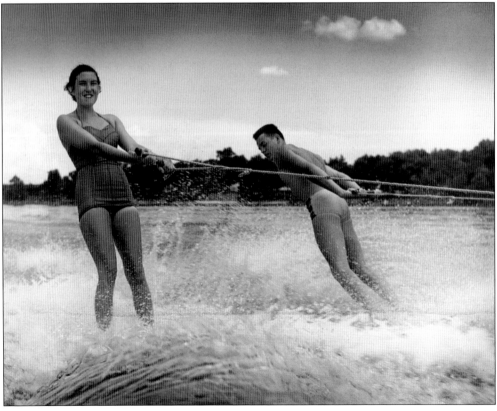

Basketball became an organized sport at Rollins in the early 1900s, reflecting an increase in the sport's popularity across the American East and South. With the need for quick thinking and fast reflexes, the sport was wildly popular for both men and women. The first Black player on the Rollins team was Laurence "Larry" Martinez, who was a leading scorer during his Rollins career.

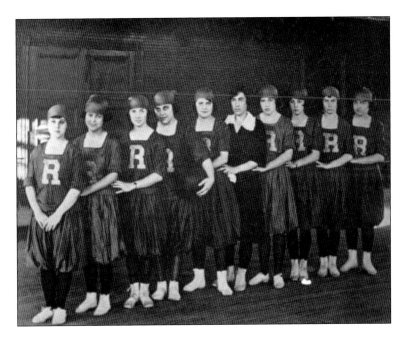

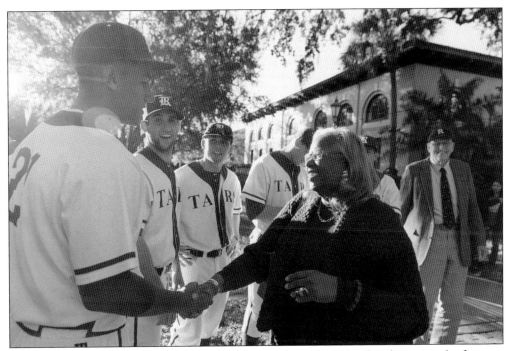

In 1895, Rollins and Stetson's baseball teams competed against each other, becoming the first-ever intercollegiate athletic event held in Winter Park. Rollins baseball earned incredible success in the game, with a win of 11-10. In 2014, the Rollins baseball team joined Sharon Robinson, daughter of baseball legend Jackie Robinson, as they added a stone to Rollins's famous Walk of Fame to honor him.

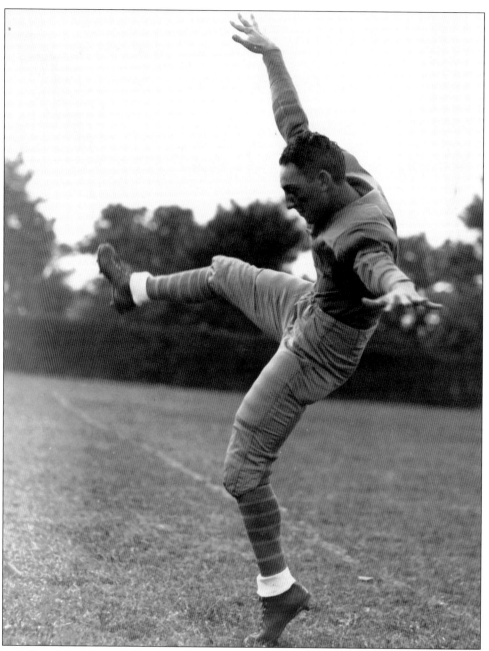

Football made its debut at Rollins in 1904, continuing for 45 years until its last season in 1949. However, the program did not run continuously, as it was paused briefly around World War I and again during World War II. Nonetheless, the Rollins football team enjoyed wild popularity and many achievements in its short lifespan. Indeed, throughout its time on campus, the team had immense success. For instance, the football team had an impressive winning streak from 1919 to 1924. But, as is true for all collegiate sports, it also endured troubling losing streaks. After losing every single game in the 1925 season, the team continued to lose most games in the next five years. The racial controversy surrounding the 1947 Ohio Wesleyan game surely contributed to the permanent cancellation of the sport at Rollins. However, Pres. Paul Wagner (1950–1951) attributes the cessation to financial reasons.

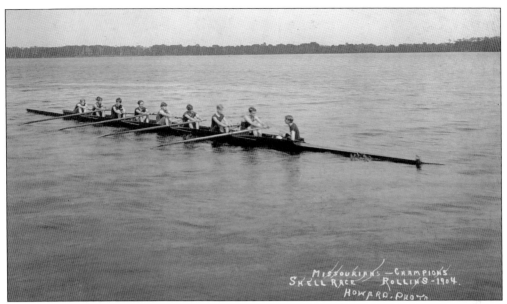

MISSOURIANS—CHAMPIONS SHELL RACE ROLLINS-1904. HOWARD·PHOTO

Crew is another sport that was established early on at Rollins, helping to shape the college's athletic identity and becoming the first collegiate rowing team in Florida. The first boats—or "shells," as they are often referred to—were acquired from a rowing club in New Jersey in 1903 and were put to use when the Viking Crew beat the P.D. Crew in the first Rollins race. Due to a lack of feasible opponents, the budding team had to race with each other. It was not until 1931 that the crew team faced its first intercollegiate opponents. Much of the Rollins Crew's advancement can be attributed to Dr. U.T. Bradley. During his time at Rollins (1934–1968), he added intramural rowing and founded the Dad Vail Rowing Association, which the Rollins Crew continues to compete in annually.

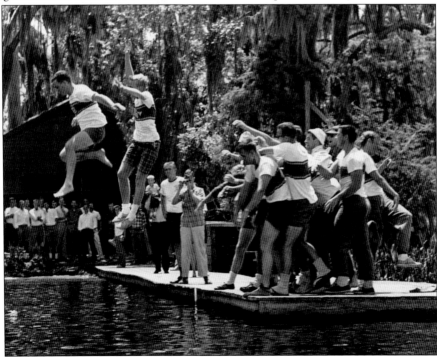

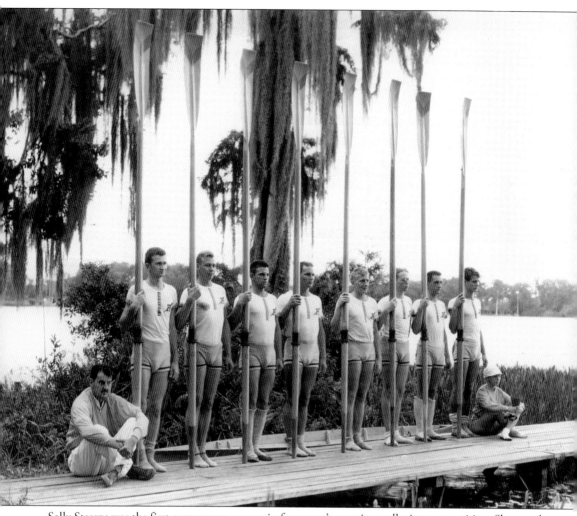

Sally Stearns was the first ever woman coxswain for a men's crew in a collegiate competition. She coxed twice, the second time leading the crew to victory against Manhattan College in 1936 disguised in men's clothing and with her hair hidden under a hat. Once this was publicized—scooped by Walter Winchell in his "On Broadway" column—it made news across the country. Unfortunately, however, Stearns has yet to receive any sort of recognition for her achievements as a coxswain. After her death in 1983, Sally's husband, Col. Robert Brown, worked tirelessly for Sally to be recognized in the Rollins College Hall of Fame. However, the committee repeatedly voted against her induction.

Rollins's first tennis club was coed and was founded in the late 1880s. Rollins was one of the first colleges to support women's tennis (since the 1930s). A long line of women's tennis stars attended the college, including Connie Clifton, whose hometown of New Smyrna awarded her a new car and radio in 1946 as recognition for her career as a nationally ranked player.

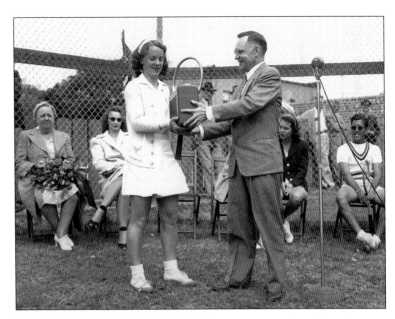

The Title IX Education Act of 1972 helped to bring women's collegiate sports off the sidelines and toward a more equal position with respect to men's sports. Before then, women athletes were exceedingly under-recognized and underfunded. The Rollins women's golf team already had a strong record pre-1972. However, in 1974, perhaps helped by the additional financial support, it won the AIAW (Association for Intercollegiate Athletics for Women) National Championship.

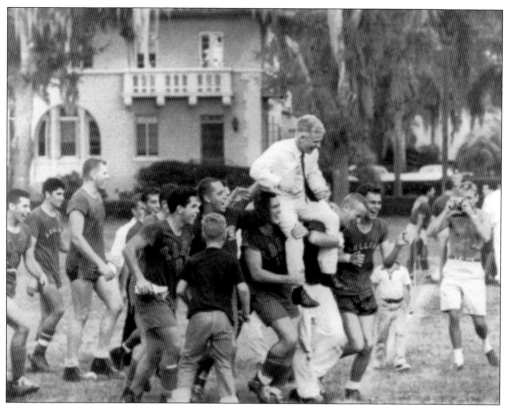

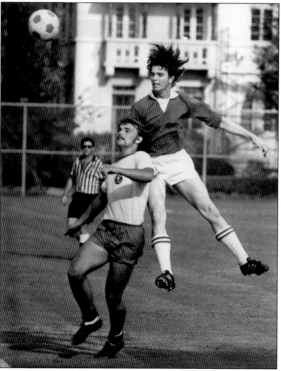

Presidential involvement has significantly shaped athletics at Rollins College. President McKean was an avid soccer fan, bringing men's soccer to the college in 1956 and remaining heavily involved with the team for the duration of his presidency. Male students jumped at the new sport, especially since football had been cut after the 1949 season. It swiftly became Rollins's premier fall sport. The men's team boasted of winning the Florida Intercollegiate Conference twice in its first four years of existence. Unfortunately, Rollins did not have a women's varsity soccer team until 1997, despite campus enthusiasm to have a female side represent the college. The team won its first game 2-1 against Palm Beach Atlantic.

Intramural sports provide students with an opportunity to engage in friendly competition and exercise without the additional stress of being on a varsity team. Additionally, they offer students a break from the rigors of the academic life. Intramurals were managed by the physical education director, and oftentimes organizations would help coordinate and lead intramural leagues. Greek life organizations have historically been at the head of intramural sports, hosting many Panhellenic tournaments. Intramurals were also an outlet to include women in sports and physical activities before the Title IX Act of 1972. Sororities often competed against each other in various activities like baseball, touch football, and swimming.

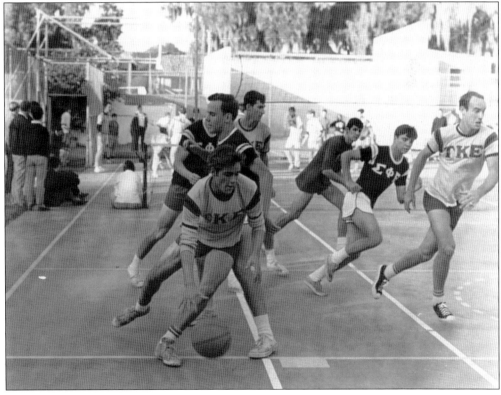

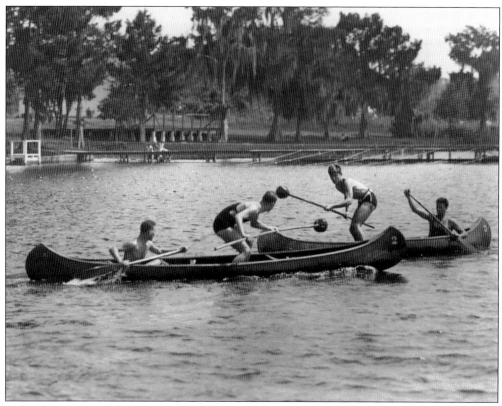

Rollins became creative with water activities, offering interesting sports such as canoe tilting and war canoe racing to students. The women's war canoe team was the Rollins College Mermaids, and they competed aggressively in the college's aquatic meets. Meanwhile, in canoe tilting, one person sat in the stern to balance and steer, as another person stood at the bow and worked to tip the other boat over.

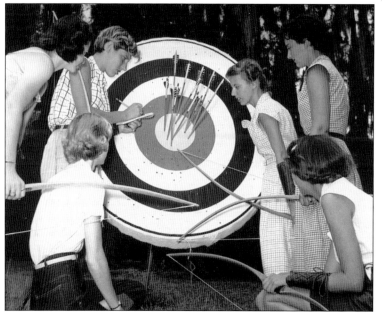

Archery and women have been inextricably linked since ancient Greece, with the goddess Artemis being a hunter. In 1904, archery became one of the first sports at the Olympics to permit female competition. With an emphasis on precision and accuracy, the graceful sport quickly attracted many female athletes at Rollins, and many enjoyed it as an intramural sport.

Skeet shooting, a recreational and competitive endeavor in which the participants attempt to break clay targets in the air, has had a long history at Rollins. Over the past century, students at the college have taken part in this sport, participating in national competitions and tournaments. Rollins student Pat Laursen won several national championship titles for her shooting talents, starting in 1938 when she was still a teenager.

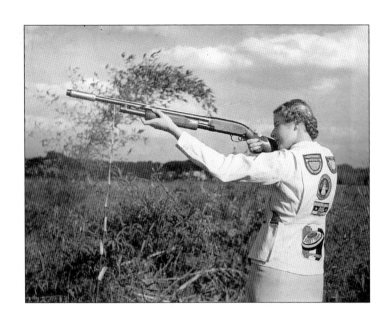

Due to Rollins's proximity to a variety of beaches, students have always been drawn to the coast. Even though it is not an official varsity sport, and club participation has been quite sporadic, surfing was and continues to be a popular activity among students. Surfing at Rollins is similar to other informal sports like yoga, pickleball, and ultimate frisbee.

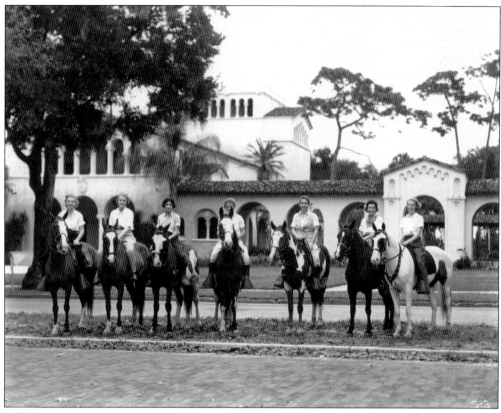

Rollins's strong connection to nature is exemplified through its long tradition of horseback riding. In the 1930s, the college established its first intramural equestrian team, which participated in competitions and horse shows regularly. While the intramural team has disappeared in recent years, the Equestrian Club maintains a large presence on campus today.

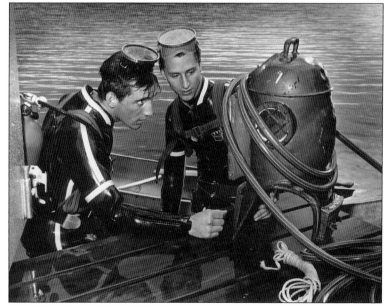

Rollins has offered scuba diving instruction since 1966. In early lessons, students were paired up so that one could venture under the water wearing a diving helmet while the other hand-pumped oxygen into the helmet from the surface. When the Aqua Lung was designed in the 1940s, students were able to dive for longer periods of time and at greater distances from the shore.

Five

SOCIAL LIVES

Creating a balanced environment of learning and living for students has always been a top priority at Rollins. College is not only a place to gain knowledge but also a place for students to attain valuable social experiences and build long-lasting relationships. The history of Rollins is filled with many college-sponsored and student-led events fostering casual yet meaningful interactions among students and their larger campus community. Over the years, students have enjoyed events like Homecoming, Fox Day—a cherished annual tradition still today—the May Day Festival, the Fiesta Parade, the Miss Rollins Pageant, and more recently, the very popular Lip Sync competition.

When students are not in the classroom, they mingle and interact in campus housing spaces. Dorm life is a unique experience for young adults, as it is often the first time a student lives away from home, taking on more independence and responsibility. Although Rollins used to have strict gender separation with dorm halls, house rules, and curfews, modern dorm life at Rollins offers both women and men a chance to bond with their fellow dormmates on an exciting journey to self-discovery. To accommodate students' various needs, many of whom are living far away from home, Rollins offers homey amenities and valued support services for campus dwellers, including on-campus dining, a nurse's office, counseling centers, and academic advisors.

Greek life is often a significant influence on college campuses, and Rollins is no exception. Local chapters emerged at Rollins as early as 1903, and the college has hosted many local and national chapters since. The college also boasts two unique chapters of Greek organizations, Non Compis Mentis and X Club, both of which still thrive today. Cementing its reputation as a party school by the 1950s, Rollins administrators have at times struggled to craft effective policies for student life with respect to drugs, alcohol, and campus safety over the years. Of course, college life is also synonymous with dating and relationships, and there are generations of Rollins alumni with love stories that started with their years as Rollins students.

Fox Day is a beloved tradition among students that has brought the campus community together for decades. Pres. Hugh McKean decreed the first Fox Day on May 17, 1956. He did this by placing a large garden figure of a fox in the middle of campus and by canceling all classes and meetings. He claimed that the day was simply too beautiful to hold class. Fox Day continued, with the actual date being a highly guarded secret each year. The earliest Fox Days were filled with campus activities such as picnics and dances, but in 1963, students pushed for permission to leave campus for the day to enjoy the beach and other activities. Their wishes were granted on the condition that all students gathered for dinner on campus. Bad behavior by Rollins students on local beaches led Pres. Jack Critchfield (1969–1978) to cancel Fox Day in 1969. In 1978, Pres. Thaddeus Seymour brought Fox Day back, and it continues to be a highly anticipated spring event.

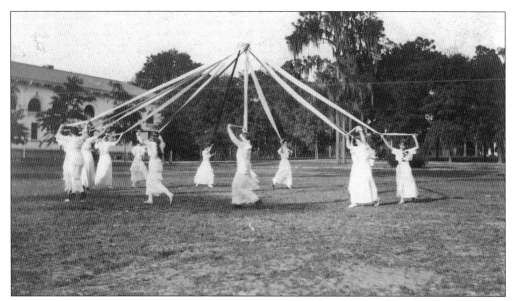

May Day is an international celebration centered around the coming of springtime and cheer. At Rollins, the event took place outside of Cloverleaf Cottage. The event consisted of the traditional Maypole dancing performed by the physical training class and the crowning of the May Day Queen. In the early 20th century, May Day became associated with communism and the 1917 October Russian Revolution, so it was discontinued in the United States.

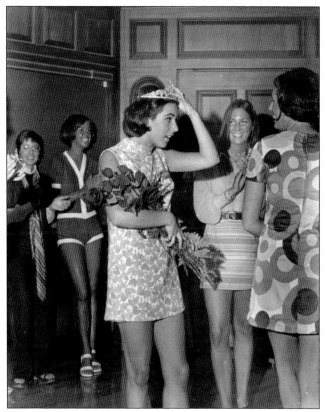

Over a dozen women competed annually in the Miss Rollins pageant, which ran from 1959 to 1971, sponsored by the Panhellenic Association. Women were judged for "beauty and poise." Winners received a trophy, a spot in the Fiesta Parade, and mentions in the yearbook and local newspapers. At right is Sheryl "Sherrie" McGee, the 1970 winner. The Miss Rollins pageant was discontinued with the onset of the feminist movement.

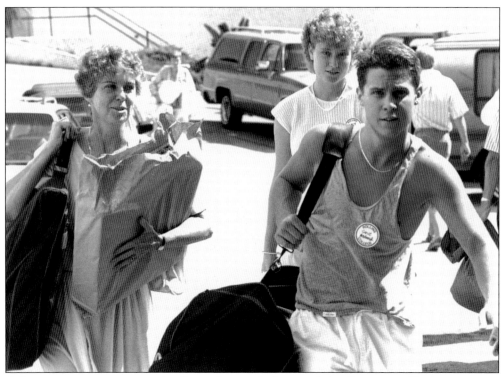

College move-in is an exciting day for students and often a sad day for parents. Until recent years, Rollins did not build large-scale dormitories to house students. Rather, it used the Cottage System, where living quarters resembled a matriarchal, Christian household. Rollins has always been a coeducational institution, but all dorms were separated by gender until 1975. First-year students could expect to be hazed by upperclassmen. In the 1920s, they were forced to wear a "Freshie hat" (also referred to as a "Rat cap") to show their rank at the college. In the 1930s and 1940s, Rollins students utilized a "Freshman's Don't Book" to lay down the rules for the newest class. There were separate editions for male and female students, and they covered subjects like manners on campus, dorm maintenance, and more.

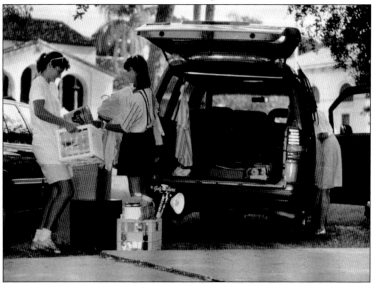

Students enjoy decorating their dorms according to their own personal style. This allows students to express their creativity, making their rooms an inviting space and helping them feel at home at Rollins. Students at Rollins have come from all over the country and the world, and in a sense, they are truly making a brand-new home for themselves.

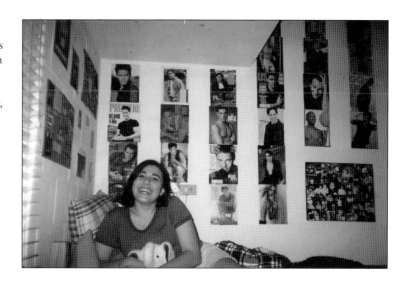

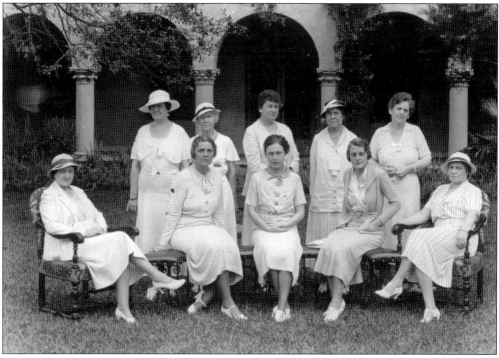

The Cottage System meant that students lived alongside matrons and faculty members. The college charged these dorm mothers with creating a similar environment to living at home with parents, enforcing rules and curfews, and imposing Christian values on the students. By the 1960s, Rollins residence halls had moved to using student resident assistants to foster a more student-focused environment.

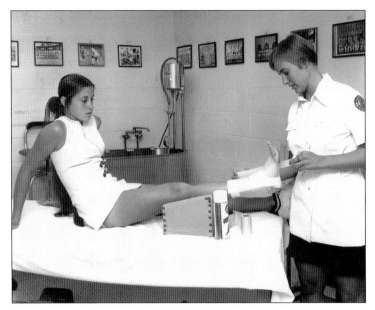

Rollins College offered many amenities and services for students to make the campus enjoyable and safe. The on-campus wellness center has had many locations on campus. From 1965 to 1987, these facilities were in the DuBois Health Center, pictured here, but medical services have been housed in the lower level of Elizabeth Hall and "the Beanery" and are currently in their own building.

The Dining Hall quickly became nicknamed "the Beanery," as there were always beans on the menu. The Beanery was a place for students to eat and socialize, and they even had the opportunity to choose the decorations in 1935. The winning theme was bugs and animals doing fun Florida activities.

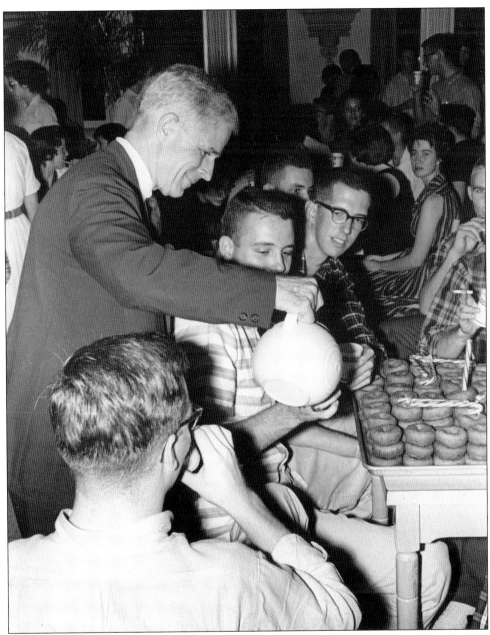

Throughout Rollins College's history, its small size has created an intimate relationship between faculty and students. Its innovative, interactive educational style extends beyond the classroom as faculty accompany students abroad on field studies, work with them on summer research projects, attend student plays and concerts, and enjoy campus celebrations such as Fox Day and the Festival of Lights together. One long-standing tradition at the college is midnight meals for students served by the faculty. Here, in 1961, President McKean pours cider at a surprise Christmas party. This tradition of midnight meals continues. Each exam period, the president hosts a late breakfast for students burning the midnight oil. The college makes other changes to help its students succeed during exams. The library is open for extended hours, and students have access to mental health counselors and emotional support dogs, providing them with resources to help them handle stress.

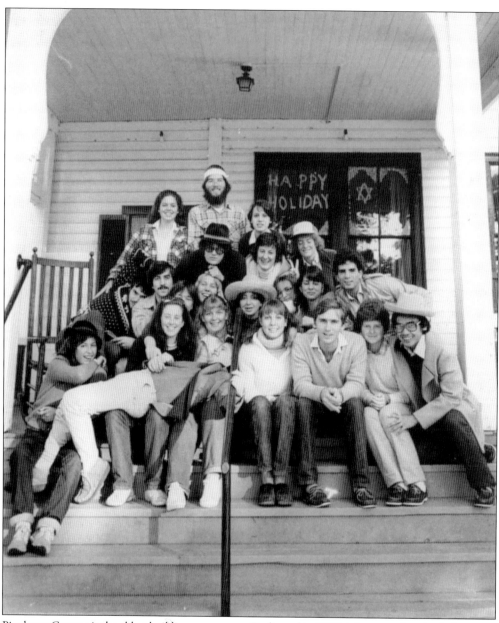

Pinehurst Cottage is the oldest building on campus. Dedicated in 1886, it has served multiple functions over the years for students including a dormitory, classroom, chemistry lab, music department, post office, and sorority house. While the building was badly damaged in the 1909 Knowles Hall fire and underwent extensive repairs, it remained the center of campus life in the 20th century. In 1974, the Pinehurst Organization was founded by the building's residents and former residents as a group of friends with philanthropic values. In the 1980s, an extensive historic preservation effort resulted in the resurfacing and relocating of the structure to a safer locale on campus. By 1985, Pinehurst was designated as a historic landmark by the Historic Preservation Commission of Winter Park. In 1987, the building became the first coeducational residence hall, and it still serves that function. The Pinehurst Organization is also still an active part of campus culture, participating in educational outreach, community service, and social justice causes.

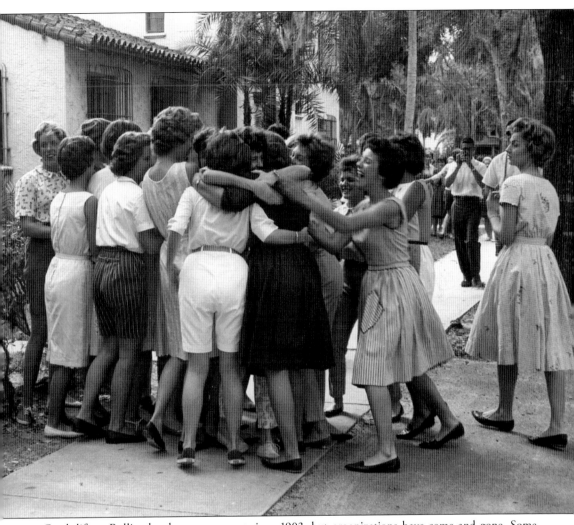

Greek life at Rollins has been a constant since 1903, but organizations have come and gone. Some chapters lasted less than a year, and others remained on campus for decades. Greek life helps students make friends and develop networks, attracting many members each year. The first sororities at Rollins included Kappa Epsilon (1903) and Gamma Phi Beta (1928). The first fraternity at Rollins was Phi Alpha (1921), which would soon merge with a national fraternity to become Kappa Alpha in 1927. Early Greek life organizations had meeting rooms in the Lyman gymnasium, and the first official campus fraternity house welcomed its residents in 1920. The longest-running fraternity at Rollins is an independent fraternity named X Club, which was founded in 1929. Fraternities and sororities have always been the head of social activities, hosting events for themselves, for Greek life, and occasionally for the entire school. Rush is an exciting day for Greek life, and on this day, students can be seen running on campus toward their new brotherhood or sisterhood.

Rollins has seen many sororities come and go over the years. One sorority that is unique to Rollins is Non Compis Mentis (NCM). Established in 1970, the founding members of NCM decided to create their own local sorority centered around values unique to the sisterhood. By not being a national chapter, members of NCM get to choose what philanthropies they support over time.

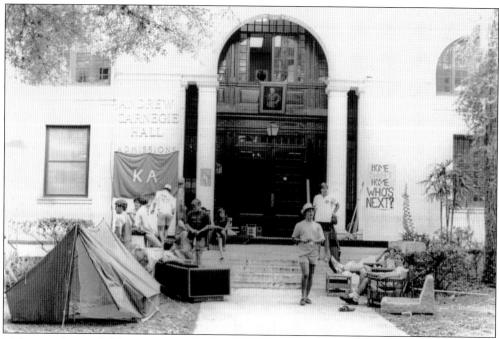

Unfortunately, Greek life can also foster bad behavior. In 1984, Kappa Alpha was kicked off campus and lost its national charter. This was due to excessive drinking, racist and sexist behavior, and general vandalism, including breaking into the Daytona Speedway annually on the morning of the Daytona 500. Despite the students' camp-in to protest their suspension, the college stood firm.

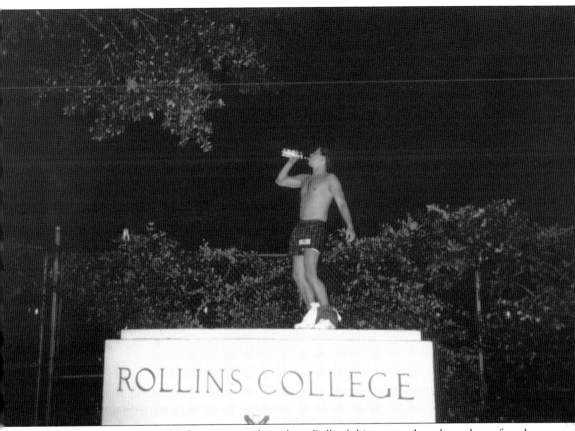

No matter what the legal drinking age was throughout Rollins's history, students have always found a way to drink both on and off campus. Greek life organizations historically have a reputation for heading drinking on campus, but other students were involved. Rollins acquired a reputation as a party school in the mid-20th century that has stuck ever since. Student surveys from across the years show that students faced a social expectation to drink at Rollins. Before 1969, Rollins was a dry campus, but this policy was not strictly enforced by any means. College administrators knew that if students wanted to drink, they would find a way. After 1973, drinking for students of the legal age was officially permitted in certain designated places. The drinking age was raised to 21 in 1984, and by the 1990s, Rollins had to address substance abuse issues and began conducting anti-alcohol and drunk driving initiatives spearheaded by President Bornstein.

In order to address growing pressure to allow drinking in the mid-20th century, Rollins proposed a safe, contained drinking space on campus in 1969. The administration approved The Pub, and it was meant to be an informal meeting place for students and faculty. This aligned with Rollins's fascination with creating a positive living and learning experience for everyone at Rollins. Also, the college hoped that by giving students a place to legally purchase and consume alcohol on campus, alcohol-related accidents off-campus and student criminal activity would be limited. This appeased students for a while, but ultimately, they wanted more. In 1970, the Booze Committee was created to consider other policies for campus drinking. In 1973, with the national lowering of the drinking age to 18, the students' requests were met, and alcohol was permitted in other resident areas of campus from then on for those of age.

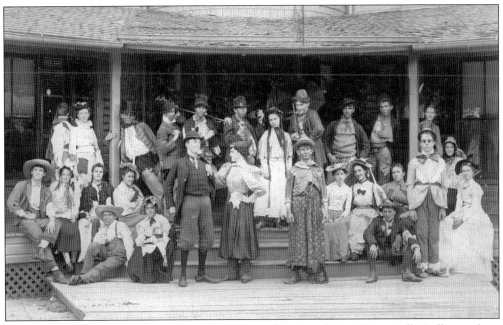

Like their peers throughout the nation, Rollins students love a good party. Historically, Rollins students hosted tamer get-togethers, many of which were themed events. Pictured above is an 1895 Tacky Party, and below is a costume party (with some rather insensitive outfits) from 1950. Other themed parties on record include a Spiderweb Party, Shadow Party, Millinery Party, and Cake Walk. The purpose of these occasions was to bring students together on campus. In more recent years, students have enjoyed typical college parties, involving kegs of beer, liquor, and drugs. Due to Rollins's lengthy time as a dry campus, most parties of this nature were held off-campus. In fact, Rollins was placed on the *Playboy* party school list in 2010. Many of these events have led to disciplinary actions against both individuals and Greek life organizations.

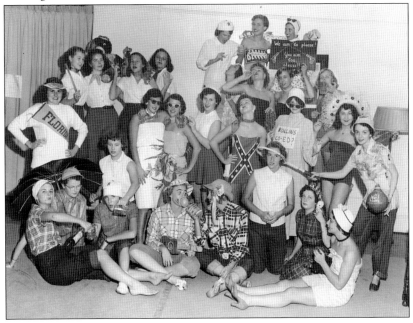

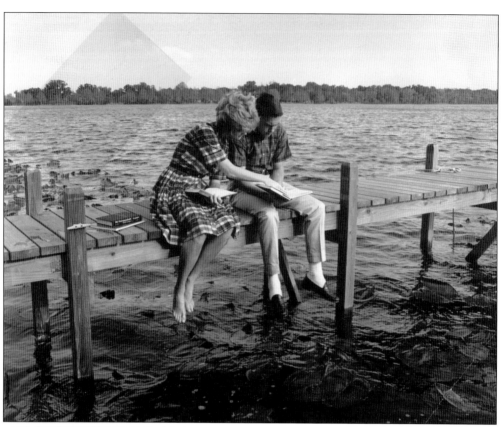

College students come into university at an age where having a significant other is wildly important. In the mid-20th century, women coming to college in search of a husband were labeled as seeking a "Mrs. Degree." Whether they lasted or not, relationships flourished at Rollins and have been commemorated on occasion by poems written by lovers. One student wrote, "Masterpiece rare: Lord how I love her! My Eva Fair."

Unfortunately, dating and relationships do not always go smoothly. Sexual assault has plagued Rollins for decades. Campus Safety emerged in 1969 as a way to take some of the pressure off of the Winter Park Police Department, and one of its main tasks was dealing with sexual assault cases. In recent years, the rate of reporting has increased, which reflects a growing concern of Rollins to protect its students.

Students enjoy spending time in common areas such as those featured here. In these spaces, students gather and socialize outside of a classroom setting. Residential buildings at Rollins were designed with this in mind. They often feature a loggia and sometimes a shared garden as well. College administrators felt that open-concept, welcoming common spaces would be beneficial in a living and learning community. These spaces were especially utilized when dorm policies were extremely strict on visitors and chaperones. Similarly, Greek life organizations rely heavily on common spaces to hold chapter meetings and other events. When the first fraternity houses were established in the 1920s, having a chapter room was a requirement.

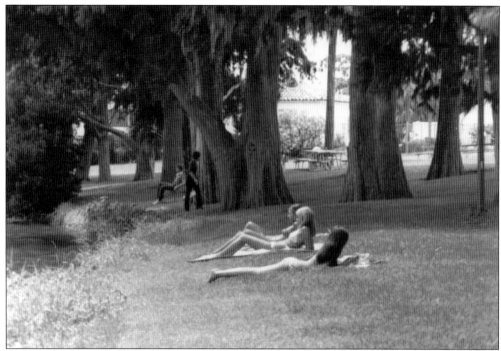

Going to college in Florida certainly has its upsides and downsides. Being able to watch space launches from Lake Virginia or getting an even better view from nearby Cape Canaveral is certainly a perk. Likewise, Florida's weather is fantastic for keeping up a nice tan, but it also means there are frequent tropical storms and hurricanes. Rollins has dealt with many hurricanes in the past, and providing aid to students during such disasters has always been the college's top priority. The same went for other disasters like the Great Freeze of 1895, yellow fever outbreaks from 1887 to 1888, and many buildings on campus burning down at least once in the college's history. No matter what they were faced with, students at Rollins always persevered.

Six

CLUBS AND CAUSES

Throughout the college's history, students have formed organizations among themselves based on common passions and projects. Rollins's earliest clubs were centered exclusively around extracurricular activities. The first club on campus, founded in the 1890s, was the Demosthenic Literary Society, a club for discussing literature and debating ideas. The next few decades saw an outpouring of similar clubs—Glee Club, the Young Men's Christian Association, and the Mandolin Club, to name a few. This period also saw the birth of Rollins's preeminent fount of student expression: the *Sandspur*. First published in 1894, the *Sandspur* has continuously operated as the voice of the college's student body to the present day. The early 20th century also saw the first published *Tomokan*, Rollins's yearbook, which ceased publication in 2007. Student expression and campus involvement underwent significant changes, however, with the beginning of World War I in 1914 and the subsequent outbreak of World War II in 1939.

The end of World War II meant a boom in students interested in being involved in the campus community. Student media thrived during this period, with the *Sandspur* becoming a highly opinionated editorial production. By the 1960s, politics became front-and-center in student life with protests against the Vietnam War in the late 1960s and early 1970s. This charged environment propelled students into campus politics and further advanced participatory roles in student government and other areas of campus life. One such student was Fred Rogers, class of 1951, who served on Rollins's Race Relations Committee, an organization that aided the local community of color.

In the late 20th century, a new generation of Rollins students was faced with new issues to take a stand on. The AIDS crisis traumatized many in the Central Florida community, and Rollins students took part in efforts to serve those who were affected. Likewise, in the 1990s and the 2000s, as the US government took aggressive military actions against Iraq, Rollins students voiced their disapproval. Though students are now able to voice opinions through e-mail and cell phones, the spirit of campus leadership and community involvement is much the same as in Rollins's earliest days.

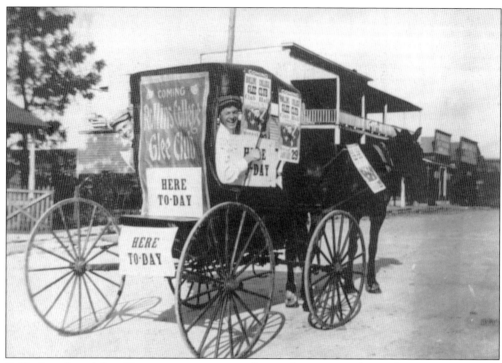

Rollins's earliest clubs—like many since—centered around extracurricular student activities. Shown here is the traveling wagon of the Rollins Boys' Glee Club. The Young Men's Christian Association of Rollins College was founded in 1895, and one of the primary functions of the YMCA was to arrive on campus a few days before the start of the school year to welcome new students. These early clubs quickly blossomed into a society and culture unique to Rollins. Over the course of the next century and a half, Rollins students have come together in many of the same ways—by joining in shared interests and advocating for personal causes.

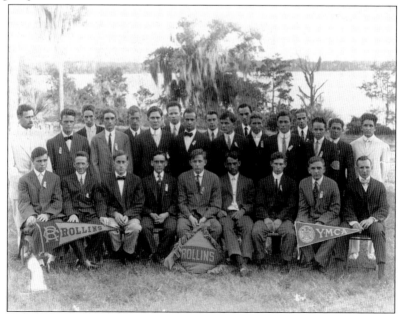

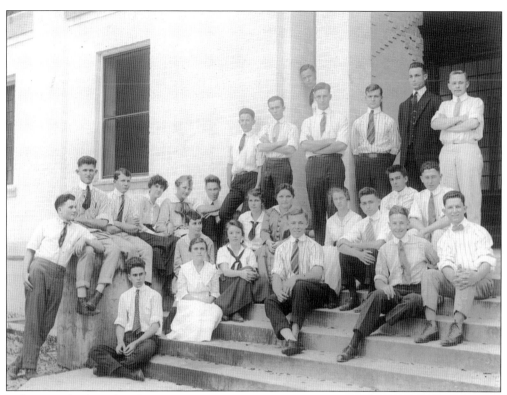

Rollins may be the only college in the country to boast a "Kracker Klub" in its history. In reference to the term "Florida cracker," as seen here around 1917, Florida-born Rollins students pridefully adopted the role of exposing non-Floridian students to the state's climate and culture. This reflected the frontier quality of Central Florida, especially to the large number of students attending from the Northeast.

The Young Explorers Club—seen here in 1934—pursued adventures in Florida and, in the summer, led field trips to exotic locations, including Africa, the Yukon, and Nebraska. Mentioned in the *Sandspur* as early as 1932, the Young Explorers also served as regional experts on archaeology projects. For example, a project funded by the Rollins Museum included the unearthing of a mastodon and mammoth fossil near Flagler Beach.

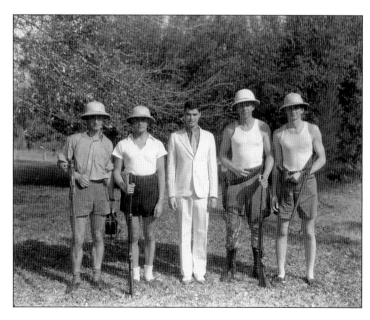

The exploration of nature has long constituted an unshakeable element of what it means to be a Tar. The Rollins Outdoors Club, pictured above in about 1990, brought students of various interests together to explore nature. Students partook in rock climbing, kayaking on Lake Virginia, and biking around Winter Park, among many other outdoor experiences.

The earliest student organization was the Demosthenic Literary Society, founded in the early 1890s, where students practiced debates and speeches. More than one century later, the Rollins Debate Team still exists as a continuation of the society's rational spirit. Shown from left to right are Dr. Eric Smaw, Melissa Fussell (class of 2013), and Chassidy Cook (class of 2013) holding the Rollins Cup debating prize after defeating Beijing Foreign Studies University in 2013.

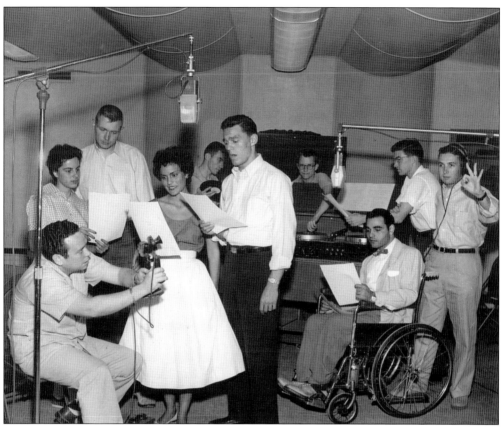

Though colleges across the United States had radio stations as early as 1912, they did not become commonplace until the mid-20th century. Rollins welcomed its own radio station in 1924—the first radio signal to broadcast from Central Florida. Physics professor Edward Weinberg chose the call sign "WDBO," standing for "Way Down by Orlando." Since 1952, the station, renamed WPRK, has broadcast myriad genres—from classical to underground—on 91.5 FM.

The Rollins *Sandspur* promotes itself as Florida's longest-running student-edited newspaper. The *Sandspur* published its first issue in 1894, eleven years after Rollins's founding. From publishing political debates on the issues of the 1960s to covering the intricate world of Greek life at Rollins in the 1980s, the paper has formed the college's journalistic backbone since its inception.

For nearly one century (1917–2007), the *Tomokan* documented the lives of Rollins students: not just their names but also their passions and projects on campus. The name "Tomokan" was intended to be a Native American word for the Floridian peninsula, but no such name ever existed. Instead, it was a corruption of "Timucua," which was erroneously used in Spanish documents to refer to all Native American people in the region.

From 1927 to 1968, the Rollins student magazine, the *Flamingo*, published a wide array of student-authored literature. In 1931, the *Flamingo* published "Two Girls," a short story by Carol Hemingway, Ernest Hemingway's younger sister. Since 1972, *Brushing* has been the voice of the campus literati, some of whom later became famous, among them Kristen Arnett (class of 2012), whose debut novel in 2019, *Mostly Dead Things*, was a *New York Times* best-seller.

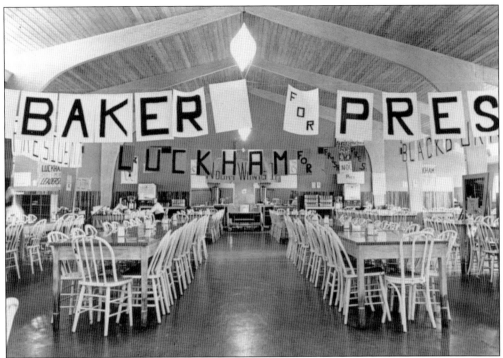

Perhaps one of the highest positions of leadership a student can take on at Rollins is that of a Student Government Association (SGA) officer. While the inner mechanisms of SGA typically eluded an uninvolved student, it would be difficult to miss the annual grand displays of electioneering. Signs adorned the Beanery (shown above) and anywhere else signs might go. During the election cycle, the *Sandspur* became thick with candidates begging for votes, and students could attend debates (shown below) to determine which candidate they preferred. Once elected, the Student Government Association took control of a mighty budget (less than $150,000 in 1985), allocating it to student organizations and campus events.

One of the issues to which Rollins students have given the most attention over the years is inclusion and diversity. In the 1950s, famous Rollins alumnus Fred Rogers served on the Rollins Race Relations Committee, which sought to serve the local community of color in Central Florida. Some of the committee's activities included volunteering at local African American schools, such as at the Hungerford School in Eatonville, an independent Black community about five miles from the college. In the 1970s, the Black Student Union started hosting Black Awareness Week on campus, which included celebrations of African American food, poetry, dance, and worship. In this photograph from the Bornstein administration of the 1990s, students organized a club for the purpose of increasing campus diversity and intercultural awareness within the Rollins student body. Such an effort demonstrated the willingness of Rollins students to develop initiatives to improve the campus around them.

REPUBLICAN

DEMOCRATIC

The Center for Practical Politics was a student-run civic engagement center that began in the 1950s. It was guided by Dr. Paul F. Douglass, a Rollins professor and former president of American University. Students within the center compiled white papers on local politics, hosted political forums, and networked with politicians from across the United States. While the center had ceased operations by the early 1970s, it engendered a spirit of democratic dialogue that infected not only the Rollins campus but also the entire Central Florida community. While this photograph shows a collegial playfulness surrounding politics familiar to the early 1960s, and especially common among the White middle class, political divisions on campus were not always so serene. Over the course of the next half-century, Rollins students would be forced to reckon with manifold national crises—Vietnam, Watergate, and 9/11, to name a few. Rollins's spirit of democratic dialogue became central to the college's ability to process these national events.

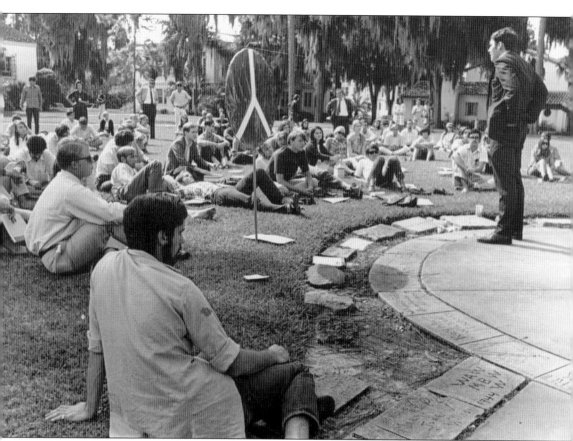

Students at Rollins, like students across the country, voiced their discontent at the US military involvement in the Vietnamese civil war. During this period, several students enlisted, and four lost their lives in military service. One student, Donald James, sparked debate across campus in 1967 when he stepped behind an on-campus military recruiting table with a sign reading "Because—U.S. is fighting unjust, illegal war; because—Human beings are dying needlessly; I URGE YOU NOT TO JOIN ARMED FORCES." In 1969, students and faculty held a large peace demonstration on Mills Lawn. Prof. David Hitchens (standing at right) spoke to an audience of about 100 students on the war. He was one of many speakers that day. The Rollins response to Vietnam was notable for its high degree of faculty involvement. In 1972, the Rollins faculty approved a resolution condemning "the continuation of the conflict that is shaping a future in which the education of our students may be rendered useless."

On May 4, 1970, the Ohio National Guard killed four students and injured nine during a Vietnam War peace protest at Kent State University. The incident sparked protests at campuses across the country, and Rollins was no exception. As seen here, Rollins students expressed such sympathy for the murdered students that police officers arrived on campus to assess the situation. The May 8 issue of the *Sandspur* hosted an array of polemics on the massacre. E.G. White, one of Rollins's earliest Black students and president of the Black Student Union, wrote, "The longer you remain silent, the more tacit support you give to a government which will supplant (or, in my opinion, has already supplanted) that of Nazi Germany in infamy."

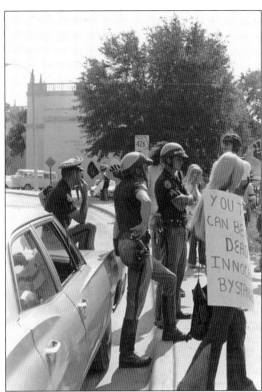

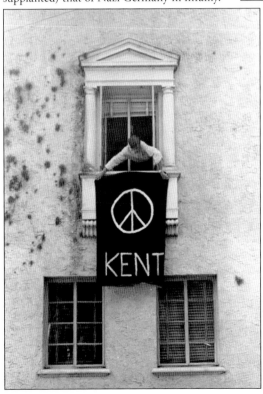

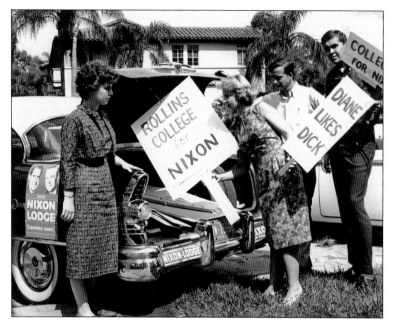

Richard M. Nixon lost the 1960 US presidential election, but that did not stop him from winning the state of Florida—one of two former Confederate states, along with Tennessee, to fall in with Nixon. The campus itself at the time was conservative-leaning, as evidenced by photographs of students wielding Nixon campaign slogans.

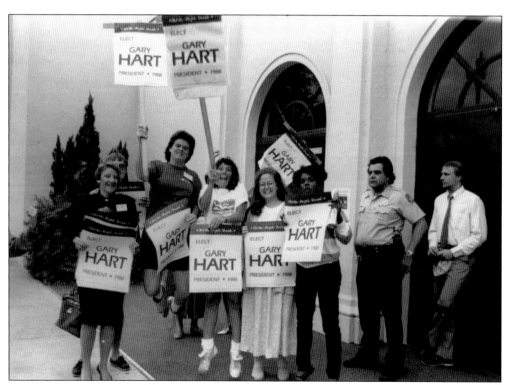

By the 1980s, the political orientation of Rollins College had not changed much. Though these students campaigned for 1988 presidential Democratic candidate Gary Hart (who ultimately lost the nomination to Michael Dukakis), the campus itself remained heavily conservative. In an informal poll hosted on campus that year by the *Sandspur*, 71 percent of the student body supported the Republican Bush/Quayle ticket.

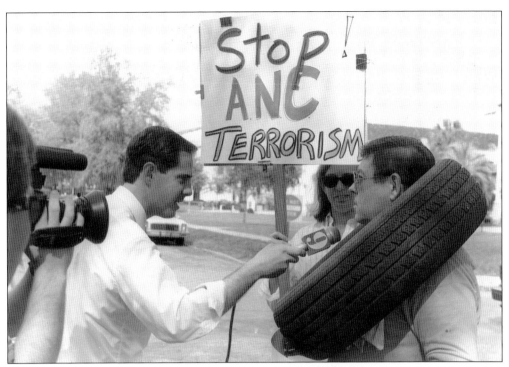

The last two decades of the 20th century continued the legacy of student protests, which started in the 1950s and 1960s. Students launched a movement for the divestment of Rollins endowment funds from corporations associated with Apartheid South Africa. In 1985, the students won, and Rollins became one of four Florida schools to divest from South Africa—one of only 155 in the nation by 1988.

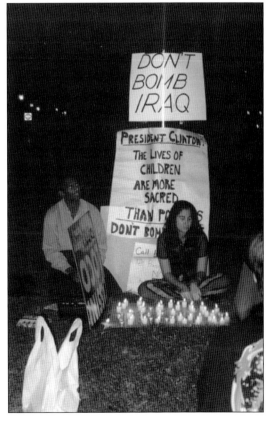

In the 1990s, student demands for peace continued. In 1997, students expressed their outrage at the Cassini space probe, which utilized more plutonium for energy than prior spacecraft. During the buildup to the 1998 bombing of Iraq, students staged a peace vigil, shown here, in protest. Though Rollins, Florida, and the United States looked quite different than in the 1960s, the demand for peace and the method of protest remained unchanged.

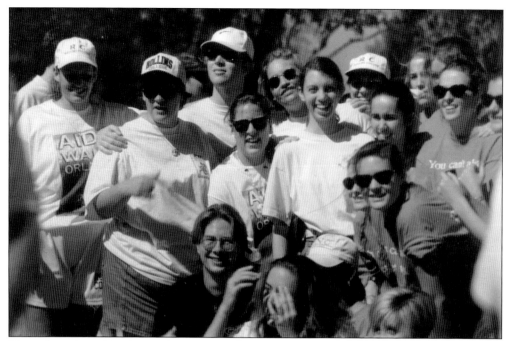

Throughout the 1980s, Acquired Immune Deficiency Syndrome ravaged marginalized communities without significant government intervention. During the mid-1980s, at the height of the epidemic, Florida ranked third in the United States for total AIDS cases. *Sandspur* articles from the period urged students to practice safe sex. In 1995, pictured here, the Rollins community participated in the first annual AIDS Walk Orlando, an annual fund-raiser to support AIDS patients and their families.

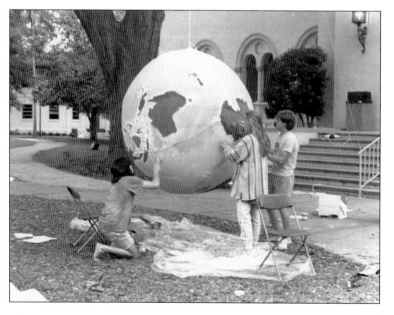

Living in the beautiful and fragile Central Florida ecosystem has long demanded Rollins students pay special attention to the environment around them. On April 22, 1970, the first Earth Day was celebrated across 2,000 college campuses. Since then, every April 22 has served as an occasion for Rollins students to come together and recognize the Earth through music, teach-ins, and nature walks.

Seven

INTERNATIONALIZATION AND CAMPUS DIVERSITY

Rollins welcomed international students as early as 1896, when Cuban students came to the college to escape the Cuban War of Independence, diversifying the otherwise all-White student body. This decision, made by Pres. George Morgan Ward, was not intended as a step toward racial inclusion but rather a result of economic necessity. Later in the college's history, Pres. Hamilton Holt launched initiatives to build a more international student body. As a result, students from Asia, Europe, and South America came to study at Rollins between the world wars.

Holt, a founding member of the NAACP, was a progressive voice in an otherwise conservative Southern setting. He advocated for peace and racial equality at times when segregation and war were the status quo. Holt also joined local initiatives that aimed to improve the lives of local Black citizens, many of whom were employed by the college. Despite these efforts, Central Florida and higher education remained segregated until the 1960s. Rollins College did not enroll its first Black student until after the passage of the Civil Rights Act in 1964. Early Black students at Rollins were recruited because of their excellence in school and athletics, and they participated in myriad other student life activities ranging from the performing arts to student government. These pioneering students also worked hard to raise awareness about racial and social justice issues on campus—matters that continue to be important to today's Rollins students.

In addition to diversifying the student body, the college also diversified the curriculum. This started in the late 1940s with the work of Prof. George Sauté, who advocated for specific courses to accommodate World War II veterans with access to the GI Bill. His championing of specialized programs that served second-career veterans and their families eventually prompted Rollins to initiate a complete and separate curriculum for adult learners called the Institute for General Studies, later renamed the Hamilton Holt School. The institute's graduate business programs gained special prominence in 1964 after Roy E. Crummer announced funding for the construction of the Graduate School of Business, which today offers an MBA and doctorate in business administration.

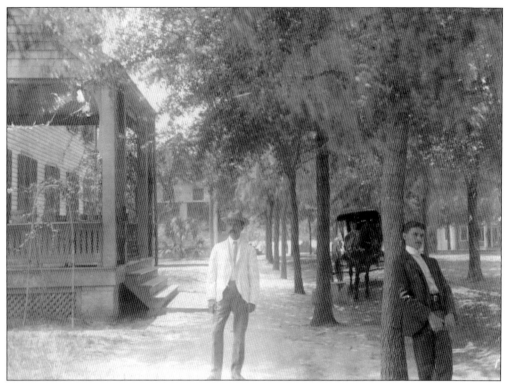

George Morgan Ward, third president of Rollins College (1896–1902), first welcomed Cuban students to campus at the request of the US military government in Cuba. The government wanted the students to escape the fighting on the island resulting from the conflict in Cuba in 1896. The international program rapidly expanded over the subsequent six years. The program aimed to teach students English, arithmetic, writing, and grammar with a later focus on specialized subjects such as chemistry or bookkeeping. Rollins benefited from Cuban students as they paid full tuition, with the exception of two—chosen by the Cuban Education Society—who went to Rollins for free. One of the earliest nontraditional student clubs was the Cuban Village, which allowed for Cuban students to celebrate their heritage while studying in the United States.

THE CUBAN VILLAGE ON ROLLINS CAMPUS.

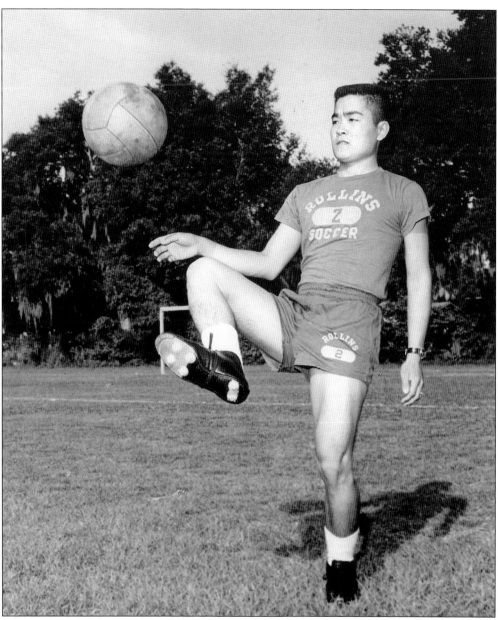

Anun Pora, class of 1961, was an international student from Bangkok, Thailand. He majored in math and business. Additionally, he played on the men's soccer team and was a proud member of the X Club fraternity. Anun, however, was not the first international student from Asia to enroll at the college. Ling Nyi Vee, from Fuzhou, China, transferred to Rollins, where she received her AB in 1929. Harry Gao, class of 1931, excelled in both academic life and extracurriculars. He was a member of the Rollins League of Nations—which consisted of international students from a range of countries studying at Rollins—and the Cosmopolitan Club. Later in life he received the Rollins Decoration of Honor in 1946 and an honorary doctorate in 1981. Gao went on to study at Yale, receiving his PhD in 1935. He returned to China and worked as a microbiologist at Wuhan University, one of the country's premier institutions. His son, George Gao Chao, also attended Rollins and was the first Chinese student to enroll after the Cultural Revolution.

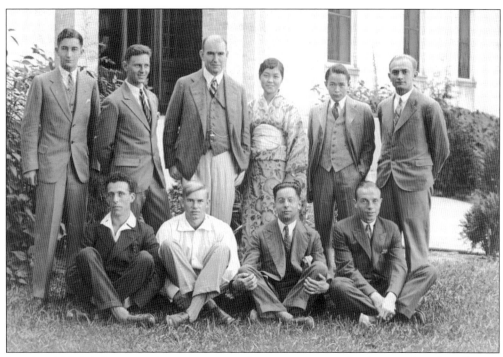

President Holt led the campus in an internationalization campaign after his arrival at the college in 1925. A journalist by training, Holt was an ardent internationalist and world peace advocate, serving as the president of the National Peace Congress and helping to found the League to Enforce Peace. He was also a strong supporter of Woodrow Wilson's League of Nations proposal, touring the country to promote American membership in the organization. One of his goals at Rollins was to diversify the academic community. Therefore, during his tenure at Rollins, he implemented programs that led to a sizable increase in international students from not only Europe but also Latin America and Asia.

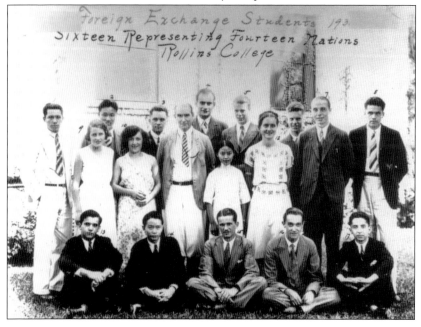

Pres. Hamilton Holt wanted to award Mary McLeod Bethune an honorary degree, but his request was denied by the board of trustees. In the segregated South, the board was unwilling to bestow such an honor on an African American. Holt was persistent in wanting to recognize her impressive career advocating for civil rights in education and serving as an advisor to Pres. Franklin D. Roosevelt. He threatened to resign but instead used his authority as president in 1948 to award the Rollins Decoration of Honor to Susie Wesley, a treasured housemaid at Rollins for over two decades. The following year, right before his retirement, Holt made one final bold statement by awarding Mary McLeod Bethune an honorary doctor of humanities degree, the first granted in the United States to a Black woman.

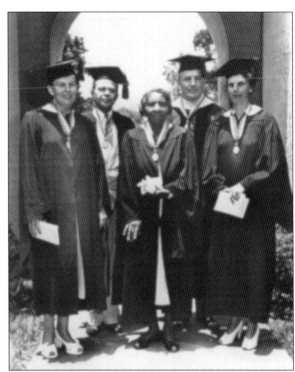

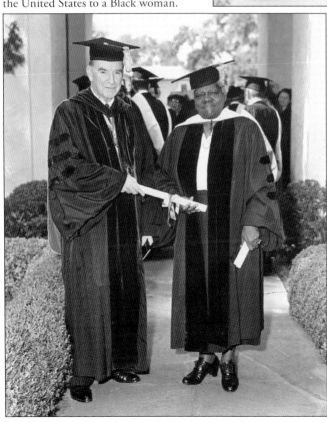

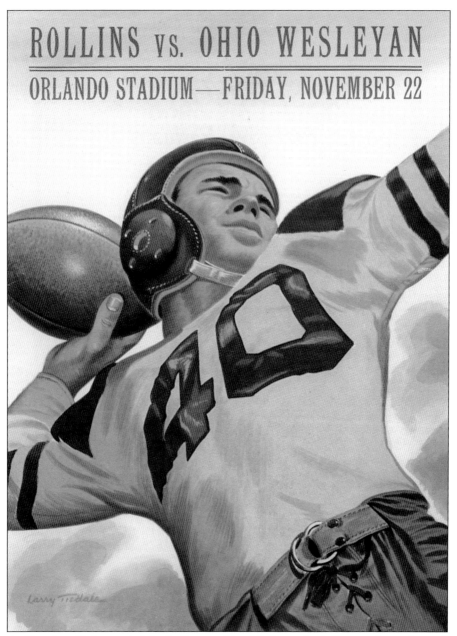

ROLLINS vs. OHIO WESLEYAN

ORLANDO STADIUM—FRIDAY, NOVEMBER 22

In 1947, Hamilton Holt canceled the Rollins vs. Ohio Wesleyan football game due to fears of racial violence. After the game had been scheduled, Rollins discovered that Ohio Wesleyan University had recruited Kenneth Woodward, an African American freshman player. With the Jim Crow laws that legalized racial segregation still in place, President Holt was reluctant to host a mixed-race game. He probably feared for the young man's safety in Central Florida, where the Ku Klux Klan was active, and worried about the response of White Southerners. On November 28, the original date of the game, Holt gathered students and faculty in the Annie Russell Theatre to explain his decision: "It seemed to all of us that our loyalties to Rollins and its ideals were not to precipitate a crisis that might and probably would promote bad race relations, but to work quietly for better race relations, hoping and believing that time would be on our side."

Laurence "Larry" Martinez was the first Black athlete recruited by Rollins since its opening in 1885. Martinez began as a freshman on the basketball team in 1967, eventually becoming team captain his senior year in 1970. Martinez's college success was not just limited to the court; he was president of the Black Student Union, a member of Lambda Chi Alpha, and graduated with a degree in sociology.

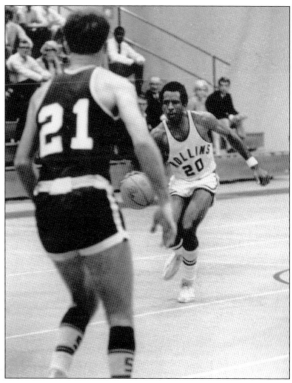

Despite Rollins recruiting its first Black female athlete in 1973, there was little coverage of these women's athletic or academic achievements during their careers at Rollins. It was only recently that six pioneering Black athletes, such as Letitia Myrick, were inducted into the Rollins Hall of Fame in 2022.

Rollins's staff and workforce have always included local people of color living in the neighboring Hannibal Square, but the student body was not desegregated until 1964 with the arrival of freshman John Cox. The college's first class of black graduates—Lewanzer Lassiter, Bernard Myers, and William Johnson—matriculated in the spring of 1970. The Black Student Union was officially chartered in the spring of 1972 but was active as an unofficial group before that. In 1969, a campus-wide petition circulated requesting more financial aid for Black students, more active recruitment of African Americans, and the hiring of Black faculty. The next year, the Black Student Union drew up its constitution and bylaws. These students immersed themselves in campus life while bringing attention to racial issues that remained significant during the time.

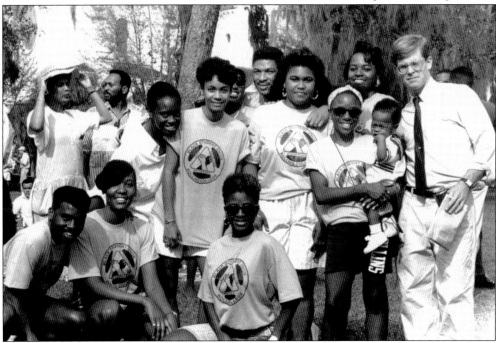

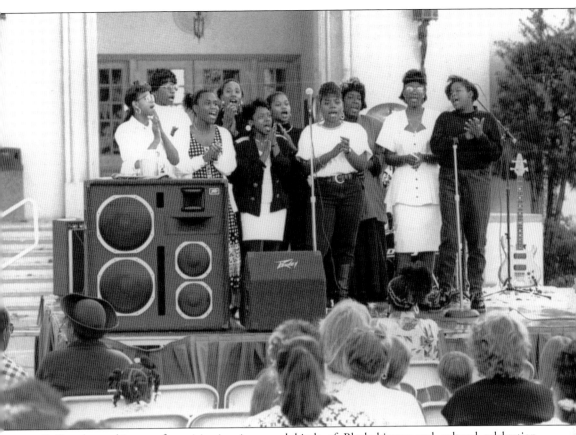

Rollins has a history of participating in several kinds of Black history and cultural celebration programming over the years. The long-lived and popular Black Awareness Week of the 1970s and 1980s transitioned to a new model in the spring of 1991. It became a multiday event called Africana Fest, which ran for several years in the 1990s. The program was intended to emphasize African cultural celebrations and honor Black heritage through a series of performances, events, and talks on campus. Anthropology faculty were very involved in this work, particularly anthropology professor Deidre Crumbley, as was the Black Student Union. As the coordinator of Africa and African American Studies at Rollins College, Crumbley described the aims of the 1991 event as "an experience which immerses participants in the music, dance, drama, cuisine, visual arts, crafts, literature, and religious experiences of people of African descent." In the 1980s, Rollins was the only school in the Orlando area to formally celebrate Martin Luther King Jr. Day as an official holiday.

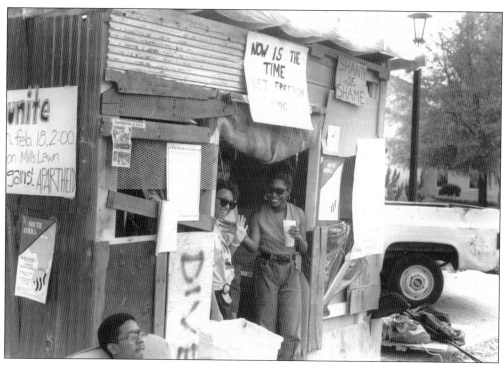

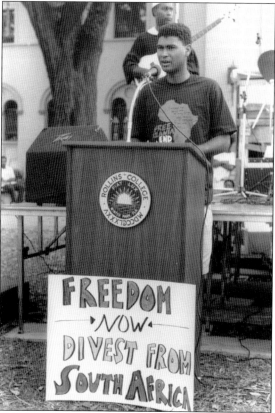

In 1990, students raised awareness about Apartheid after discovering that the board of trustees held investments in South Africa. The Cultural Action Committee (CAC) at Rollins planned an anti-Apartheid rally in early February. The demonstrations consisted of student-led speeches in addition to the construction of a pop-up shanty placed on Mills Lawn known as "the Shanty of Shame." The shanty was staffed by students and provided information to those curious about the ongoing issue of Apartheid. In addition, Makaziwe Phula Mandela, daughter of political prisoner Nelson Mandela, was invited by the CAC to speak to students about issues surrounding segregation in her home country. "A Protest Against Apartheid" was given in the Knowles Memorial Chapel on February 19 at 8:00 p.m. and was broadcast live on WPRK.

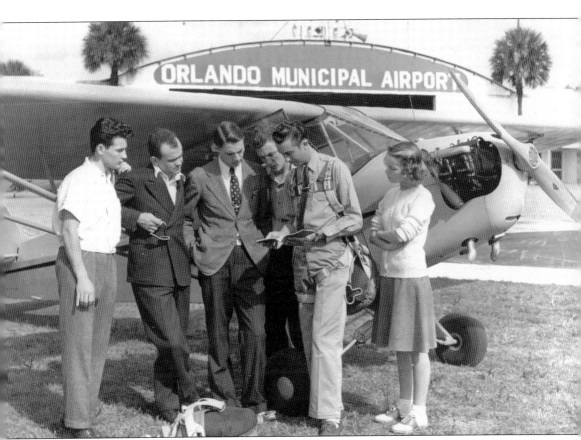

Rollins College was one of the first educational institutions to provide courses in piloting during the early 1940s after the US government launched the Civil Aeronautic Authority (CAA) Program. The original Orlando Airport, four miles from campus, was used as the training base, accommodating student pilots enrolled at Rollins. Students were required to attend "ground school classes" three nights a week; classes included the history of aviation, civil air regulations, navigation, the construction and use of parachutes, and the theory of flight. Students completed a total of 90 groundwork hours and 35 hours of flight lessons, which they took during the day. By the end of the course, these pilots would engage in cross-country flying, flaunting their new aviation skills consisting of 720-degree turns and figure-eight maneuvers. Any student between the ages of 19 and 26 who passed the physical examination and proved satisfactory in the academic work could join the program, with a small percentage of places allotted to women.

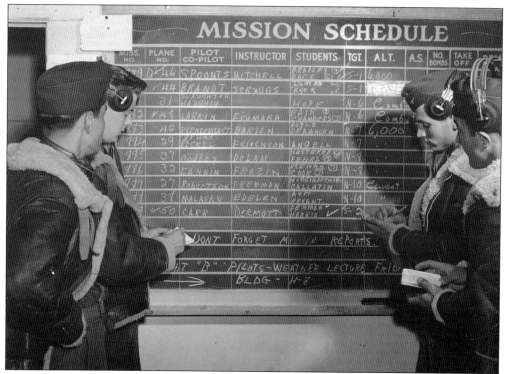

The CAA Program was attractive to students despite its selectivity. Before being accepted, individuals were put through an intensive preliminary physical examination that required applicants to have 20/20 vision and accurate hearing in each ear. Once accepted, however, success rates were high, with only a few individuals dropping out over the course of the program.

The Specialized Training and Reassignment (STAR) Unit lived on campus from 1943 to 1944; college officials and representatives of the Army signed a contract to allow this accommodation. These men had completed their basic training and then had the opportunity to take refresher classes. Every day they marched singing to classes and lined up at attention on the lawn at 5:00 p.m., altering the dynamic of life at Rollins.

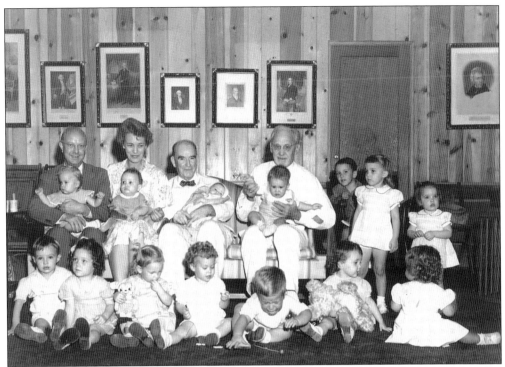

Pictured is President Holt with the children of enrolled students at Rollins in 1946. Despite parents not fitting the traditional college student stereotype, Rollins welcomed nontraditional students as early as 1930. In the beginning, adult learning took the form of short "winter lectures" for visiting snowbirds. Over time, however, the evening learning program at Rollins evolved dramatically. Prof. George Sauté was hired by President Holt as an assistant professor of mathematics in 1943, teaching physics and mathematics for the Army's STAR program. In the postwar years, he implemented education courses for returning World War II veterans. Rollins College established an extension campus at the nearby Patrick Air Force Base, which continued until the base closed in 2004. In 1969, President McKean awarded Professor Sauté the Rollins Declaration of Honor for his commitment to encouraging adult education.

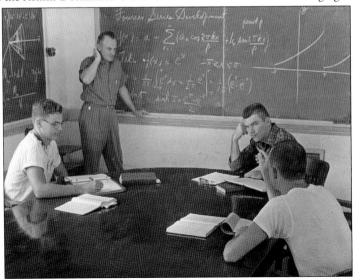

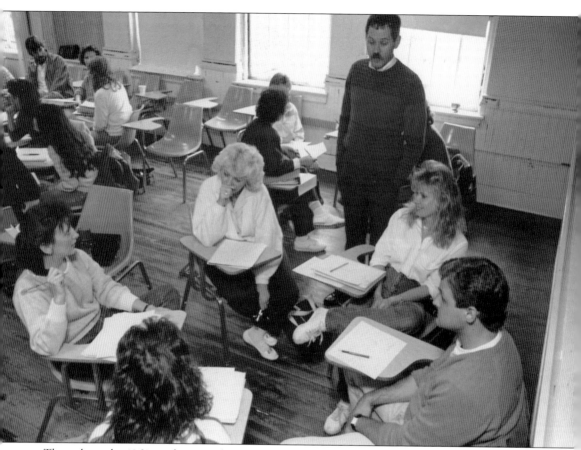

Throughout the 1960s and 1970s, the evening school of Rollins went through substantial changes. The School of Continuing Education, which was eventually renamed the Hamilton Holt School in 1987, added numerous undergraduate and graduate degree programs under Pres. Thaddeus Seymour's direction. The Hamilton Holt night school quickly became popular with a vast array of eager students ranging from ages 17 to 75. The variety of nontraditional students included full-time workers, single parents, and older adults. To be accepted into the program, applicants needed to have received their GED; no SATs, ACTs, transcripts, or other records were required. The school catered to these students' needs by offering refresher courses, helping them acclimate to academic life. Evening courses also appealed to students who were in a financial gray area; tuition was (and is) substantially cheaper than a traditional semester as a full-time undergraduate in the day school.

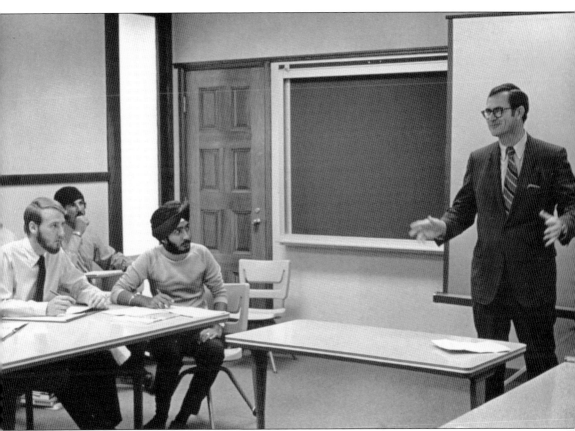

In the fall of 1957, Rollins College initiated a graduate program in business administration for employees of major industries in the Orlando–Winter Park area with the aim of improving skills through study at the graduate level. The original program offered classes including business statistics, international trade, marketing management, and business law. Dr. Charles Welsh, the first dean of the graduate program, supervised the construction of Crummer Hall, which was dedicated in 1966. The original building consisted of ten classrooms, two large lecture rooms, and two seminar rooms. One million dollars for its construction was donated by Roy E. Crummer, a wealthy businessman from the Midwest who had moved to Winter Park in the early 1930s. The new building provided a grander space for students to excel in their graduate studies. By 1969, Crummer students had the opportunity to study while abroad as part of their education. The business school's reputation grew quickly as the program expanded. In 2019, it was recognized by *Forbes* magazine as being one of the best business schools.

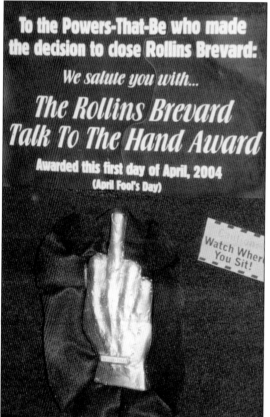

To the Powers-That-Be who made the decision to close Rollins Brevard:

We salute you with...

The Rollins Brevard Talk To The Hand Award

Awarded this first day of April, 2004
(April Fool's Day)

Watch Where You Sit!

The Patrick Air Force Branch of Rollins College opened in 1951 and offered evening classes to veterans who wanted to further their education after World War II. The program offered an array of courses taught by Rollins faculty, including accounting, business law, and principles of economics. In 1988, the program was rebranded and physically moved to Brevard County on Florida's Space Coast. Initially successful, the campus enrolled over 300 students each term. These students were encouraged to join student life despite studying on a separate campus. As time progressed, Rollins Brevard Campus came under fire. Traditional students complained that the separate campus had untrained faculty and was not accredited by the American Assembly of Collegiate Schools of Business, tarnishing the reputation of Rollins College. The complaints, in conjunction with declining enrollment, led to Rollins College Brevard Campus closing in 2004.

Eight

TOWN AND GOWN

Rollins College and Winter Park, having grown up together over the course of nearly one and a half centuries, share a close and complex relationship. Local issues often cross into campus and vice versa. This deep connection goes back to the town's early history. Were it not for the people of Winter Park, Rollins College would likely have been built somewhere else—Daytona, Jacksonville, Mount Dora, and Orange City all submitted proposals to host Florida's first college. Winter Park was chosen because the town managed to outbid all other cities by almost four times.

The heart of Winter Park has always been Park Avenue. While today it is lined with a plethora of boutiques and restaurants, the street originally had more humble beginnings. Over the years, a panoply of ice cream parlors, retail shops, bars and restaurants, and other hangout spots have entered and exited the Park Avenue scene, making it a favorite destination for Rollins students in search of off-campus entertainment. Of course, after 1971, Walt Disney World offered both recreation and summer jobs to Rollins students, albeit with a much longer commute.

Rollins administrators, especially Pres. Hamilton Holt, were often ahead of the times in terms of their approaches to race relations. However, at least for the early 20th century, people of color were limited to service and labor roles both at the college and in Winter Park. Like many Southern towns, Winter Park conflated race divisions with physical ones during its early history—one side of the railroad tracks was for wealthy White people, and the other side was for poor Black laborers. This division was intentional, not accidental, as it was platted in the town's original plan. Rollins too was an intentionally segregated place for many decades; the college did not admit African American students until the mid-1960s. Today, however, Rollins and Winter Park are more diverse communities.

Rollins students and employees have developed and led service projects within the Winter Park community since the college's earliest moments. Local volunteerism is a tradition that continues today in programs like Habitat for Humanity and SPARC Day.

While Disney World officially arrived in Central Florida in 1971, Rollins enjoyed a strong relationship with the theme park even before it opened. In 1970, during the planning for Disney World, the incoming administrative manager of the Reedy Creek Development District, Donald Greer, participated in an Earth Day panel on campus. Since then, the Rollins/Disney relationship has blossomed. Rollins students frequent the park, and Disney employees likewise frequent the campus. In fact, many students choose Rollins for its proximity to the theme park. Shown here is a Rollins student selected to participate in the Disney College Program, a prestigious internship opportunity in which students live, work, and study at Disney World. The presence of Disney World, Universal Studios, SeaWorld, and other attractions has given Central Florida a tourist economy. For Rollins students, however, it means a community of cultural diversity and intersecting perspectives. In fact, about 50 percent of Rollins students come from outside the state of Florida—many of them having learned of Rollins during trips to one of the area's many parks.

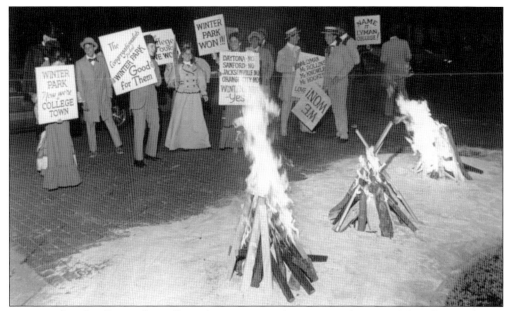

Winter Park and Rollins College effectively grew up together. In 1935, the city and the college celebrated the 50th anniversary of the decision to build Rollins in Winter Park rather than another Florida town with an event dubbed Establishment Days. The bonfire seen here, with students costumed in 19th-century garb, was part of the centennial celebration in November 1985.

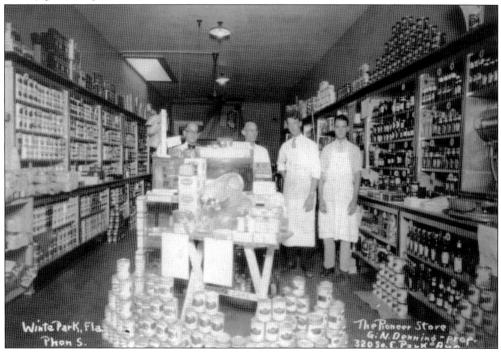

Those living on campus in Rollins's early days had limited shopping options. The most useful was the Pioneer Store. This general merchandise store first opened in the summer of 1882 and was initially operated by John Ergood and Robert White Jr. The second floor of the building encapsulated the frontier nature of early Winter Park, serving as the town's post office, church, town hall, and school.

1932 MEMBERSHIP CARD

THIS CERTIFIES THAT

IS A MEMBER OF THE

Winter Park Chamber of Commerce

"THE CITY OF HOMES"

WINTER PARK, ORANGE COUNTY, FLORIDA

Carter Bradford

SECRETARY AND TREASURER

ROLLINS PRESS

Much of the Winter Park economic world has blossomed around, beside, and within the Rollins College campus. A wide variety of local businesses and nonprofits trace their roots to the college. As early as 1932, the college was a pivotal force within the Winter Park Chamber of Commerce. Here is a membership card printed by Rollins Press for the chamber. Even in the 21st century, local philanthropy has played a role in shaping the college campus. For example, in 2004, the Rotary Club of Winter Park aided Rollins in constructing a stadium for the school's softball team (shown here).

Close to the heart of campus for much of Rollins's existence was the "Dinky Line" (the colloquial name for the Orlando & Winter Park Railway). A short and slow train line that, in its heyday, ran from Oviedo to Orlando, the Dinky was constructed in 1889 by two local railroad developers. It was acquired by the Seaboard Air Line Railroad Company, which operated lines throughout the US Southeast, in 1902. The origin of the name "dinky" is somewhat unclear. Some sources suggest it refers to a class of train, others to a variety of mule, and others still that it simply described the dilapidated nature of the train. The line was removed in 1969, but not before it could claim its share of victims—one 1952 *Sandspur* front page bore the headline "Dinky Runs Over Woman."

Since Rollins's founding, students have arrived on campus through all possible means of transportation. Central to the interaction between Rollins and Winter Park, though, was the railroad. Since the first one was constructed in 1882, the approximate location of Winter Park's train station has shifted little from its original home just one block from Park Avenue. The procession of students from the station to the campus was an annual occurrence, with the president and faculty members journeying down Park Avenue to greet the new freshmen. During this time, locals could spot Rollins freshmen a mile off due to the signature "rat cap," which they wore during their first semester until Thanksgiving Day.

The Animated Magazine was a live lecture series that invited the entire Winter Park community to explore intellectual topics through the magazine's speakers. It demonstrated the literary culture of the campus (and the celebrity connections of its president). It was the brainchild of Hamilton Holt (left) and Prof. Edwin Osgood Grover (right). Though the tradition failed to live past 1969, it was revived in 2007 as the Winter Park Institute.

Rollins College today stands out among Southern colleges for its lack of homecoming festivities—but this was not always the case. Throughout the 20th century, Rollins held annual alumni homecomings, complete with a parade, bonfire, and football game. This photograph shows the November 1949 parade.

The Fiesta Parade, seen here in 1953, was held every April from 1937 to 1967. Rollins students designed floats and drove them along Park Avenue in downtown Winter Park. The Fiesta King and Queen led the parade, and classmates lined up for blocks to cheer on floats and friends. Many of the Fiesta Parades would be considered cultural appropriation today, such as a Native American–themed event.

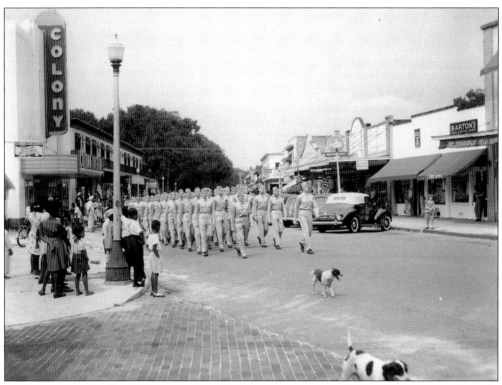

For the entirety of Rollins's history, students have been a common sight on Park Avenue. Only rarely, however, have they been seen in military uniform marching down the street. Rollins hosted an advanced technical training cohort during World War II called the STAR Unit. Housed in the Pinehurst dorms, the STAR Unit contributed to the war effort by hosting blood drives and collecting scrap metal.

Central Florida was populated by indigenous peoples when Europeans arrived. The bloody history that followed under Spanish, French, English, and American rule left a legacy that has repercussions today. In 1990, President Seymour and Tina Marie Osceola—former student and member of the Seminole tribe—laid a stone in the Rollins Walk of Fame to commemorate Chief Osceola. Nonetheless, Rollins College still lacks a land acknowledgment statement.

Similarly, well into the 20th century, relations between Rollins and African Americans reflected earlier patterns. People of color still primarily inhabited roles of labor and service. Toward the end of the century, African Americans took on greater roles at the college. One of Rollins's first Black faculty members, Alzo J. Reddick, was later elected to public office and served for 18 years in the Florida House of Representatives.

While Rollins's first students of color came to the college in 1964, it is important to remember that community members of color had a complicated relationship with the college since its founding. Many citizens of Hannibal Square, the segregated African American neighborhood of Winter Park, worked at Rollins College as maids, gardeners, and construction workers. Shown here are two photographs from the 1930s. In one, an unidentified Black woman poses for a student's art project playing the role of a Native American. In the other, headmaster of the Hungerford School—a segregated Black school in Eatonville—Capt. John E. Hall poses in a campus nativity scene. These photographs of local Central Floridians of color invite us to reconsider and question the nature of Black life on campus prior to the 1960s.

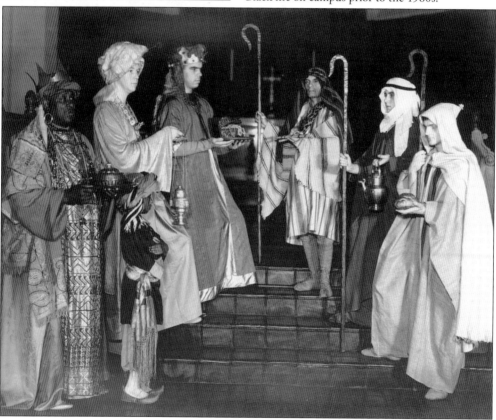

While Rollins's attitudes toward race have gradually evolved, the college has always stressed civic participation. Due to enduring economic disparities, African American communities are often most in need of this help. Rollins students have long been active members of their local community, providing services and help both as part of coursework and in the form of extracurricular activities, such as the Community Service Club, shown here in 1955. Since the presidency of Thad Seymour, Rollins College has regularly partnered with Habitat for Humanity, constructing free housing in Hannibal Square for low-income residents. Habitat for Humanity provides the materials, while Rollins students, staff, and faculty provide the labor.

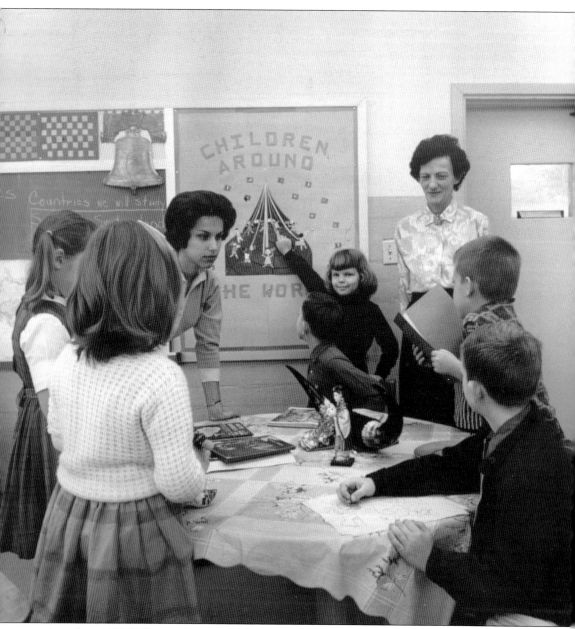

As early as 1965, Rollins students engaged in community service by volunteering their time as student instructors at Fern Creek Elementary School in Orlando. Fern Creek, located in an older neighborhood, had a high population of students of color, many of them economically disadvantaged or even homeless. Over the years, the school partnered with a variety of organizations from SeaWorld to the YMCA to bring innovative education to its student body. Forty years later, the relationship between Rollins and Fern Creek was just as strong, with the new Center for Leadership and Community Engagement assisting students in locating volunteer opportunities near and far. The Fern Creek Student Teaching program served as a demonstration of Rollins's intense commitment to community service, which still exists today. Unfortunately, the school district closed Fern Creek in 2018, but Rollins remains close partners with other local volunteer organizations.

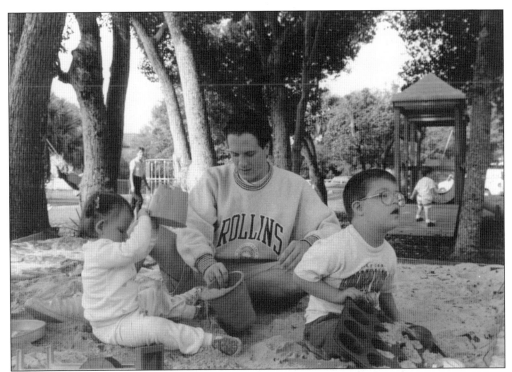

The Child Development Center at
Rollins College was opened in 1975 by
the Rollins psychology department to
be used as a "laboratory preschool" for
Rollins undergraduates. CDC students
come from all corners of Winter Park—
many of them related to Rollins faculty,
others of them simply community
members. Student instructors at the CDC
simultaneously serve the community
and develop their teaching skills.

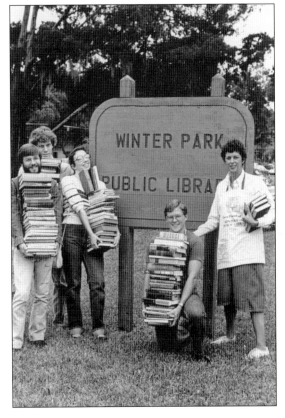

The Winter Park Library has a history
as long as that of Rollins. Initiated in
a meeting of nine local ladies in 1885,
the library has had five locations within
Winter Park. The strong relationship
between the college and the library is here
symbolized by students donating books,
an experience led by Polly Seymour,
wife of then-president Thaddeus.

While Rollins students served the town, the town constituted a critical part of the students' social lives. Many Winter Park businesses stopped at nothing to win over the student audience. One business that did not have to try too hard was Harper's Tavern, which sat just across from the college on Fairbanks Avenue. Harper's Tavern was initially a feed store. Reopening in 1932 as a saloon, it was a hub for student frivolity until it burned down in 1996. Though a reopening was planned in 2002, after financial setbacks this too went up in smoke. The tavern was never to return to Winter Park, and students were forced to find other locales to frequent.

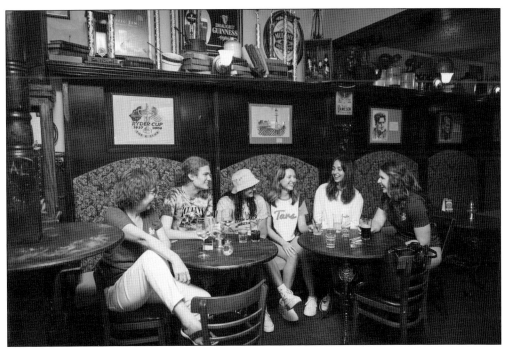

Students and faculty from Rollins College still enjoy the many bars and restaurants near campus. Preeminent is Fiddler's Green, a beloved Irish pub. Haunted by students who come for the live music and community feeling (not to mention the proximity to campus or its Guinness), "Fid's" simultaneously holds a place in Rollins's history and present. Seen here are the authors—from left to right, Claire Strom, Liam King, Peyton Connor, Reagan Cooney, Helen Hutchinson, and Rachel Walton—celebrating the last day of work on this very book.

DISCOVER THOUSANDS OF LOCAL HISTORY BOOKS FEATURING MILLIONS OF VINTAGE IMAGES

Arcadia Publishing, the leading local history publisher in the United States, is committed to making history accessible and meaningful through publishing books that celebrate and preserve the heritage of America's people and places.

Find more books like this at
www.arcadiapublishing.com

Search for your hometown history, your old stomping grounds, and even your favorite sports team.

Consistent with our mission to preserve history on a local level, this book was printed in South Carolina on American-made paper and manufactured entirely in the United States. Products carrying the accredited Forest Stewardship Council (FSC) label are printed on 100 percent FSC-certified paper.

MADE IN THE USA